St. Marys Ontario Book 2 in Colour Photos, Saving Our History One Photo at a Time

Photography
by Barbara Raué
2015

Series Name:
Cruising Ontario

Book 130: St. Marys Book 2

Cover photo: 67 Peel Street South, Page 19

Series Name: Cruising Ontario
Saving Our History One Photo at a Time in colour photos

Books Available in Alphabetical Order:
Aberfoyle, Acton, Alton, Ancaster, Arthur, Aylmer, Ayr, Bloomingdale, Brantford, Burlington, Caledon, Caledonia, Cambridge, Clifford, Conestogo, Delhi, Dorchester to Aylmer, Drayton, Drumbo, Dundas, Eden Mills, Elmira, Elora, Fergus, Guelph, Hagersville, Hamilton, Hanover, Harriston, Hespeler, Jarvis, Kitchener, Linwood, Listowel, London, Lucknow, Mono, Mount Forest, Neustadt, New Hamburg, Niagara-on-the-Lake, Oakville, Orangeville, Orillia, Owen Sound, Palmerston, Peterborough, Port Elgin, Preston, Rockwood, Seaforth, Sheffield, Shelburne, Simcoe, Southampton, St. Jacobs, St. Thomas, Stoney Creek, Stratford, Tillsonburg, Waterdown, Waterford, Waterloo, Wellesley, Wingham

Book 110: Lucknow, Mitchell
Book 111: Conestogo, Bloomingdale
Book 112: Delhi
Book 113: Waterford
Book 114-116: Waterloo
Book 117-119: Windsor
Book 120-121: Amherstburg
Book 122: Essex
Book 123-124: Kingsville
Book 125-127: Woodstock
Book 128: Thamesford
Book 129-132: St. Marys

Other Books by Barbara Raue

Coins of Gold

Arrows, Indians and Love

The Life and Times of Barbara
Volume 1: Inventions That Have Enhanced My Life
Volume 2: Entertainment That I Have Enjoyed
Volume 3: East Coast Trips
Volume 4: Olympics Have Always Intrigued Me
Volume 5: Wonders of the World
Volume 6: Caribbean Cruises We Have Enjoyed
Volume 7: Animals
Volume 8: Storms and Other Major Disasters in My Lifetime
Volume 9: Wars, Terrorist Attacks and Major Disasters

The Cromwell Family Book

Laura Secord Discovered

Daddy Where Are You?

Visit Barbara's website to view all of her books
http://barbararaue.ca

Table of Contents

Ontario Street North	Page 6
Ontario Street South	Page 7
Park Street	Page 11
Parkview Drive	Page 13
Peel Street North	Page 14
Peel Street South	Page 15
Queen Street East	Page 20
Queen Street West	Page 39
Architectural Terms	Page 53
Building Styles	Page 56

St. Marys is a town in southwestern Ontario located southwest of Stratford. It is known as Stonetown and is set in a beautiful valley beside the majestic Thames River. St. Marys' early economic success depended on the mills powered by the water in this river. The town's prosperity was also helped by the presence of accessible limestone, taken in blocks from the riverbed and from quarries along the riverbanks. The term "Stonetown" is an apt moniker for St. Marys, as the town is filled with unique architecture featuring locally-quarried limestone. The stone buildings reveal much about the town's history, and the development of the town can be witnessed in the architecture.

John Grieve Lind (1867-1947) was closely associated with the start of the St. Mary's Cement Company. St. Marys was chosen as the location for the plant because of its abundance of limestone, clay and water, it was on two national railway lines, and it had access to hydro-electric power from Niagara Falls. The plant opened in 1912.

Once the cement plant was in operation, Lind turned his attention to parks and recreation. He purchased the seven acre Cadzow Park on Church Street South and built Cadzow Pool. Lind Park now contains a statue of Arthur Meighen, Canada's ninth prime minister.

From stunning architecture to picturesque views, St. Marys has a special character all of its own.

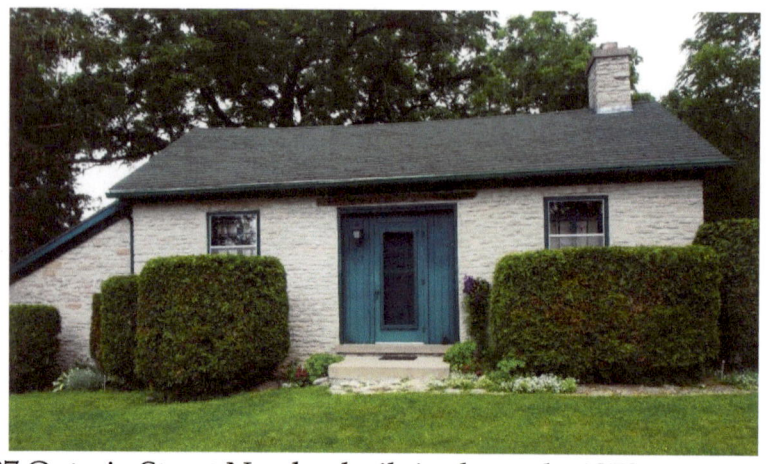

107 Ontario Street North – built in the early 1870s as a stone barn for retired farmer John Henry Clark at the back of his property at 108 Robinson Street. It is built on a hill and the rear is two-storeys.

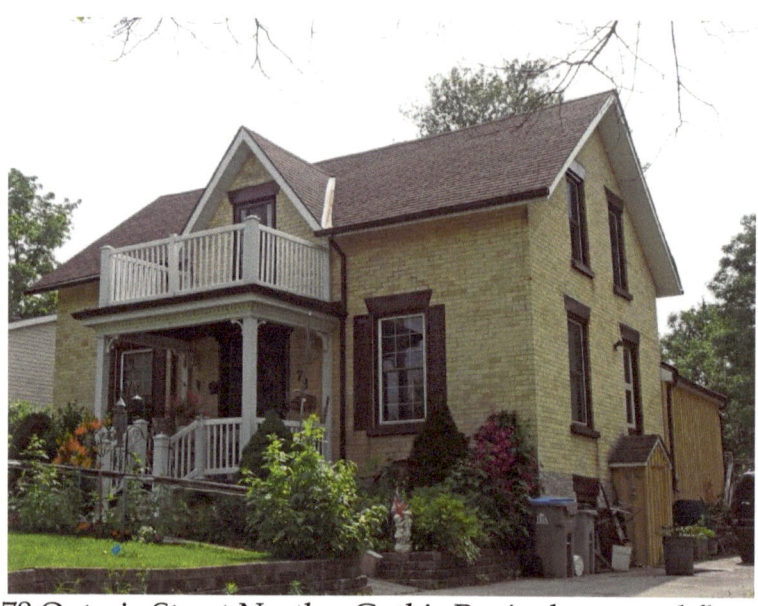

78 Ontario Street North – Gothic Revival – second floor balcony

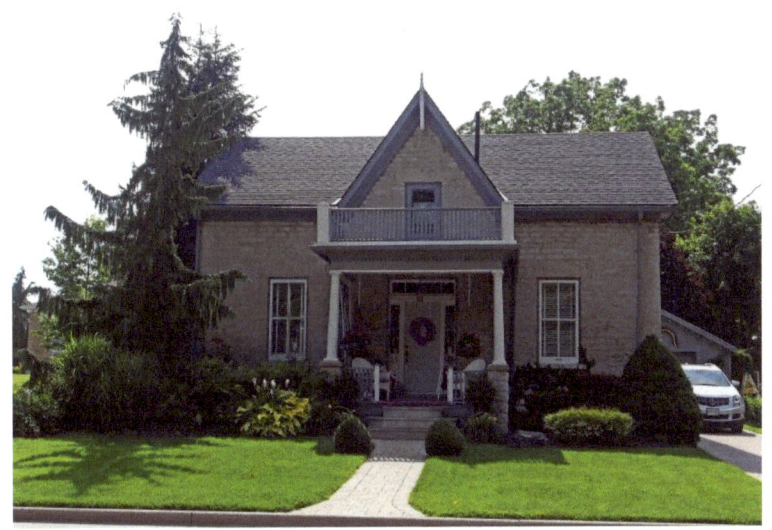

26 Ontario Street South – Gothic Revival – second floor balcony, finial on gable, sidelights and transom around door

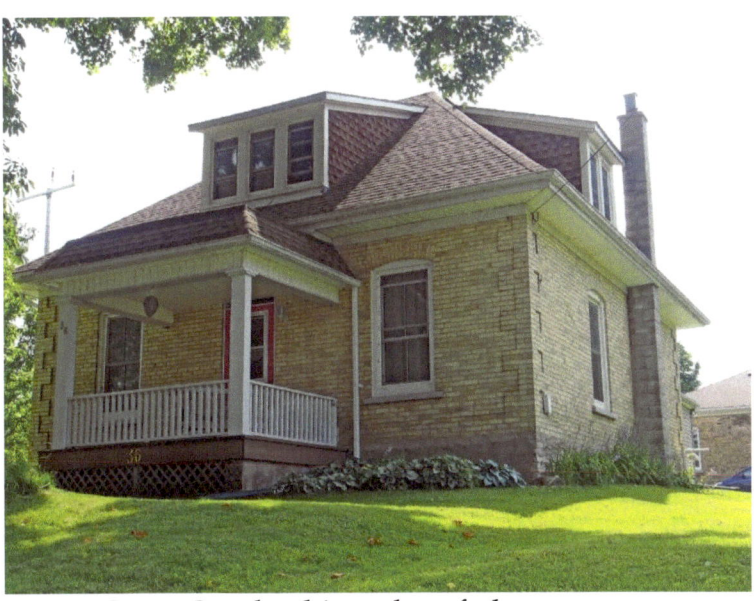

36 Ontario Street South – hipped roof, dormers, corner quoins

31 Ontario Street South - vernacular

35 Ontario Street South – one-storey cottage, corner quoins, hipped roof

48 Ontario Street South – Cape Dutch style - gambrel roof

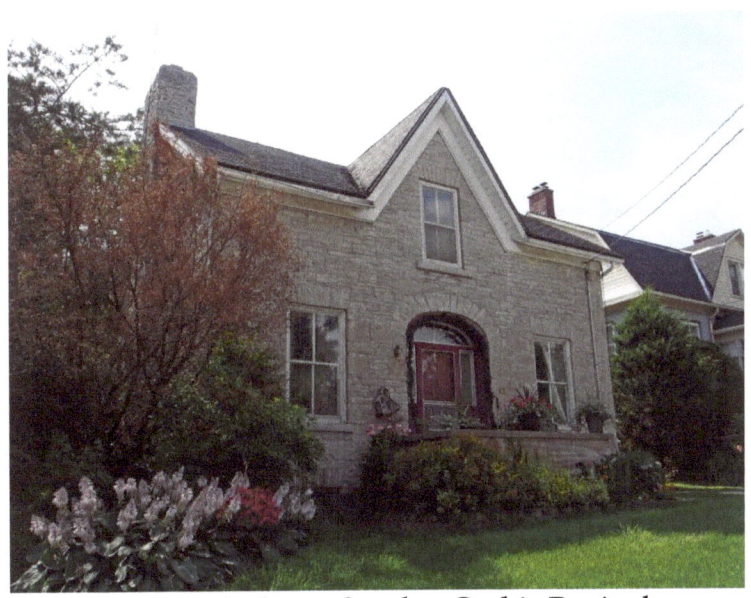

52 Ontario Street South – Gothic Revival

72 Ontario Street South – Italianate, hipped roof, two-storey bay

94 Ontario Street South – Gothic Revival, pediment

Park Street

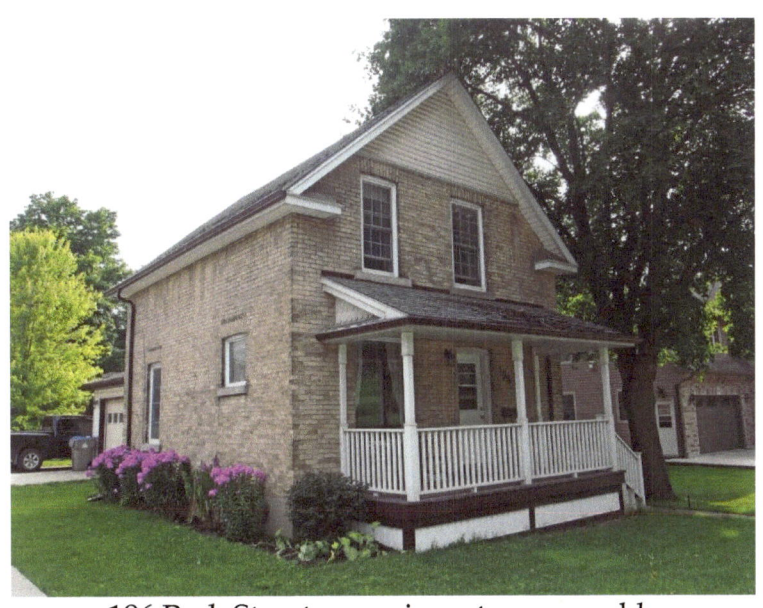

196 Park Street – cornice return on gable

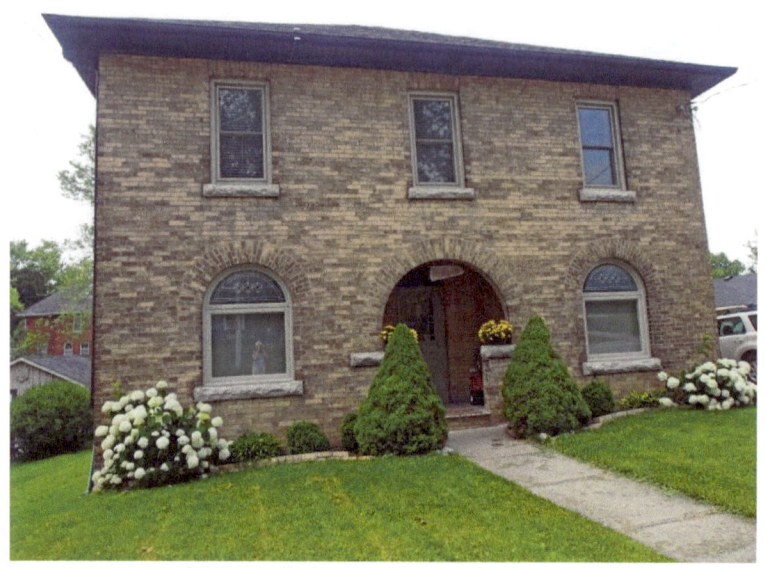
245 Park Street – hipped roof

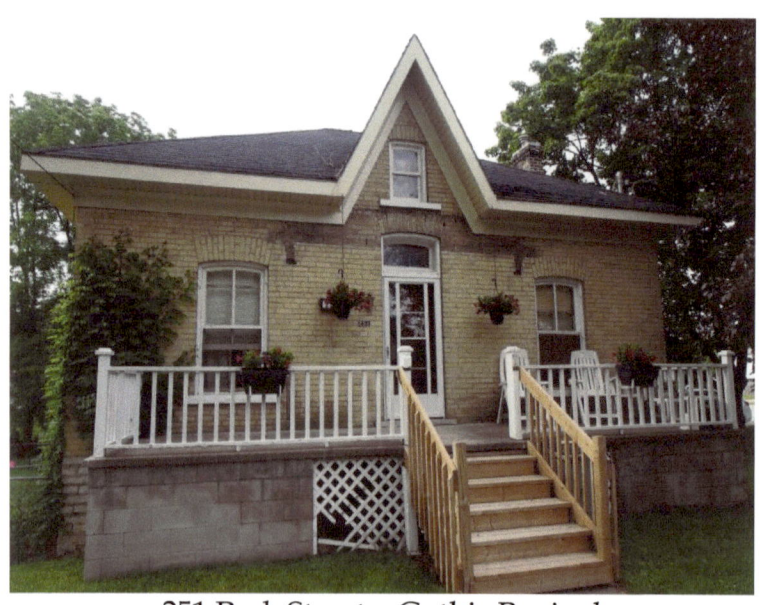
251 Park Street – Gothic Revival

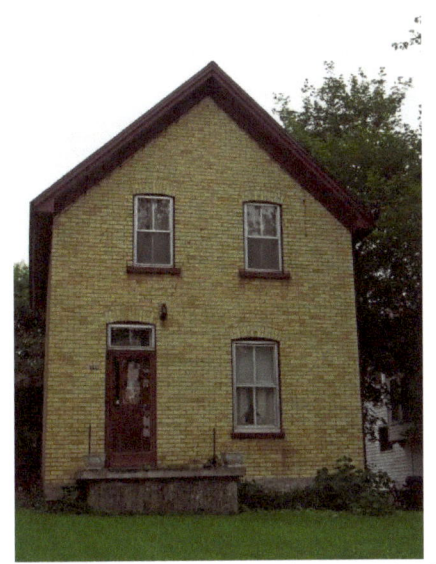

246 Park Street – Gothic Revival

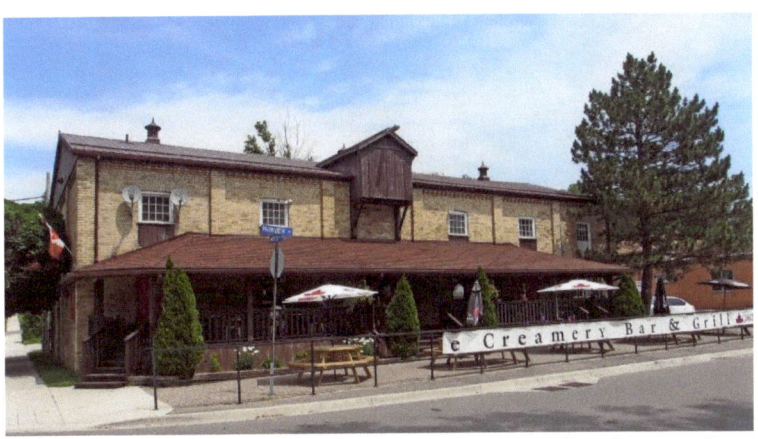

Parkview Drive – Creamery Bar and Grill – formerly a planing mill owned by J. D. Moore

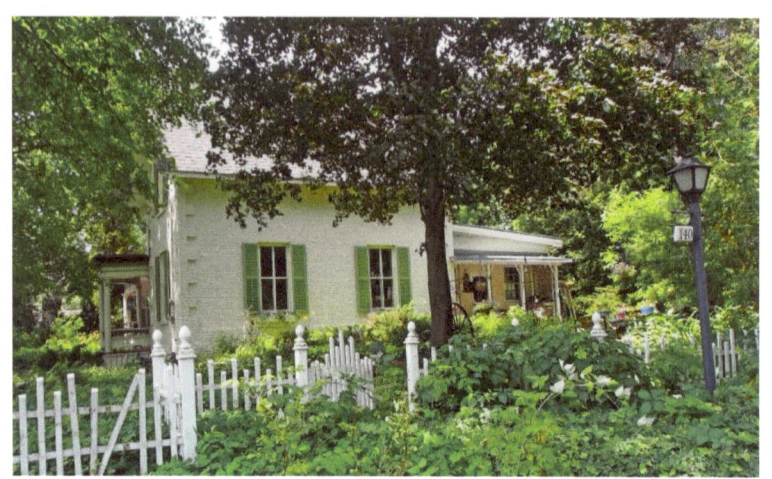

140 Peel Street North – corner quoins

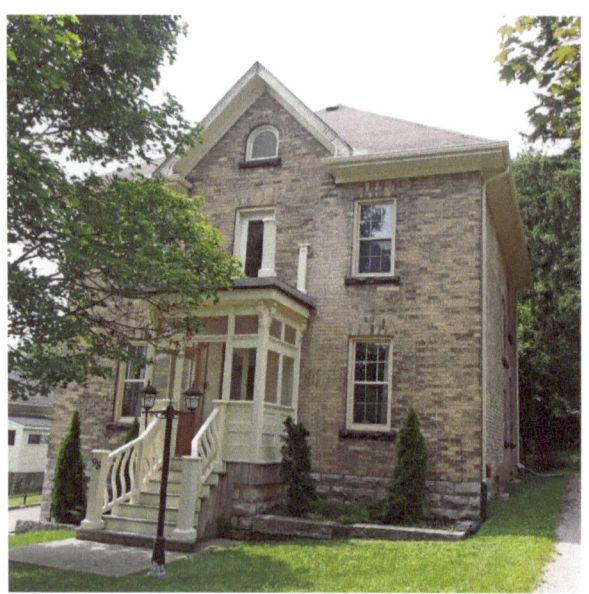

98 Peel Street North – c. 1910 – hipped roof

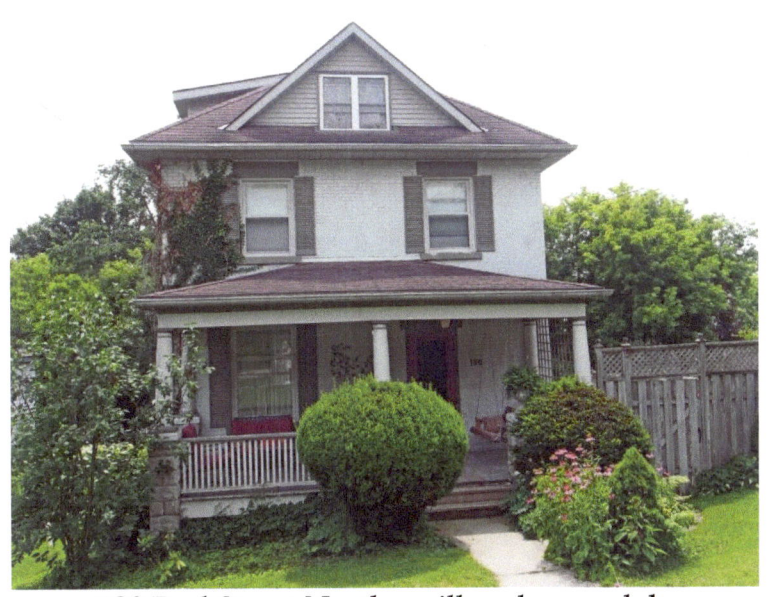

190 Peel Street North – pillared verandah, dormers in hipped roof

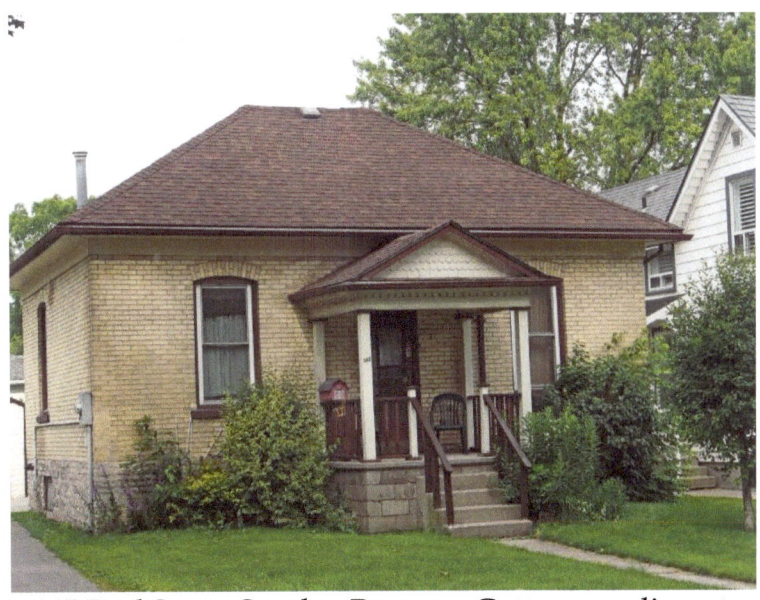

145 Peel Street South – Regency Cottage, pediment, hipped roof

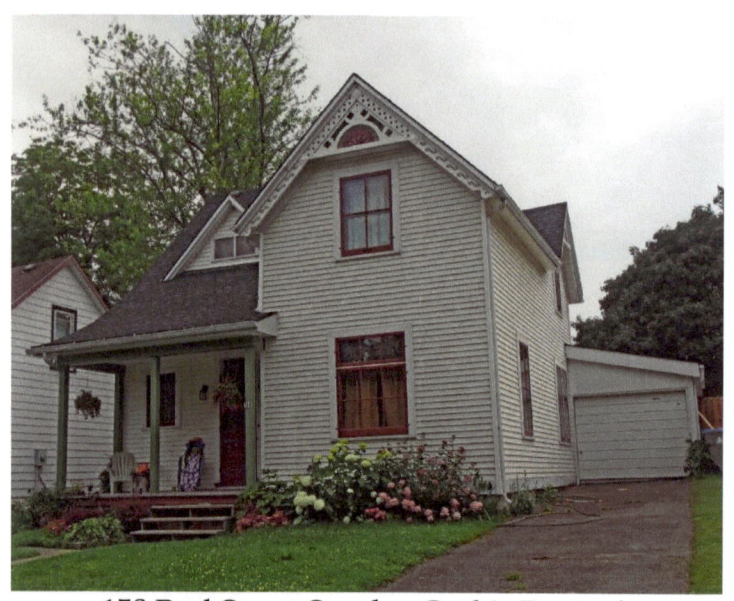

158 Peel Street South – Gothic Revival, verge board trim on gable

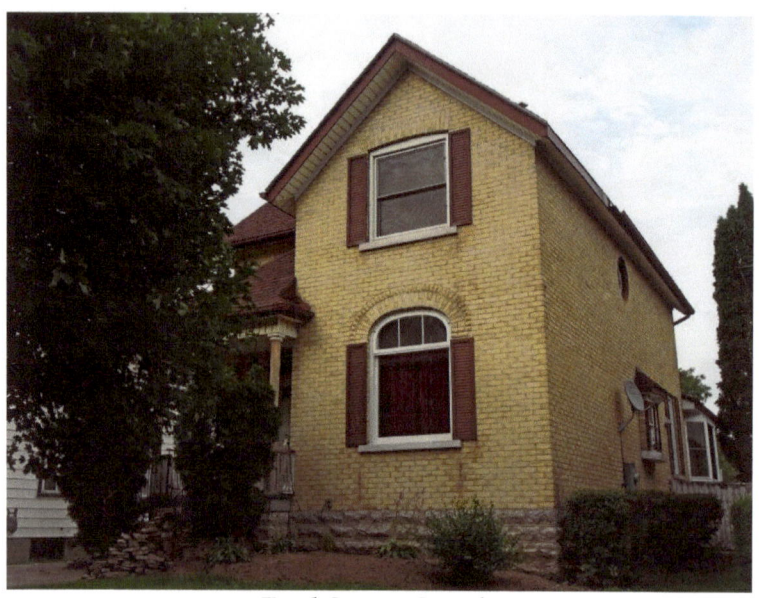

Peel Street South

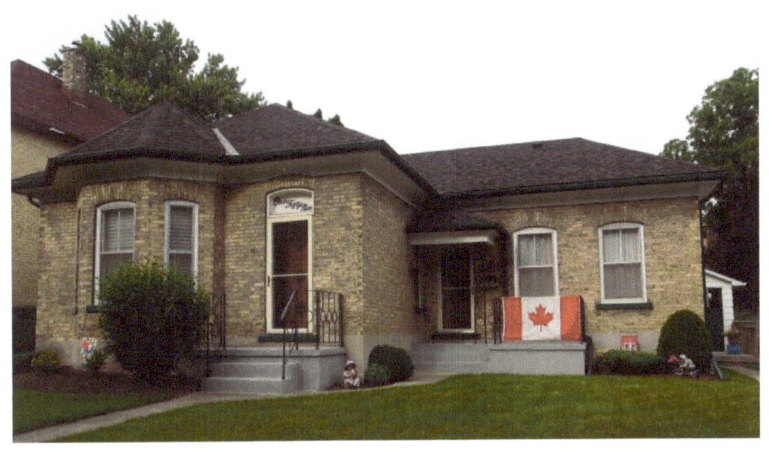

159 Peel Street South – bay window – hipped roof

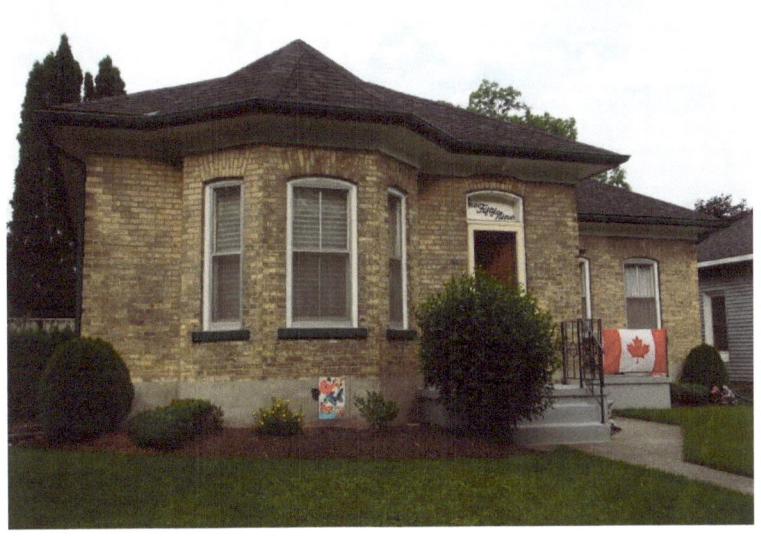

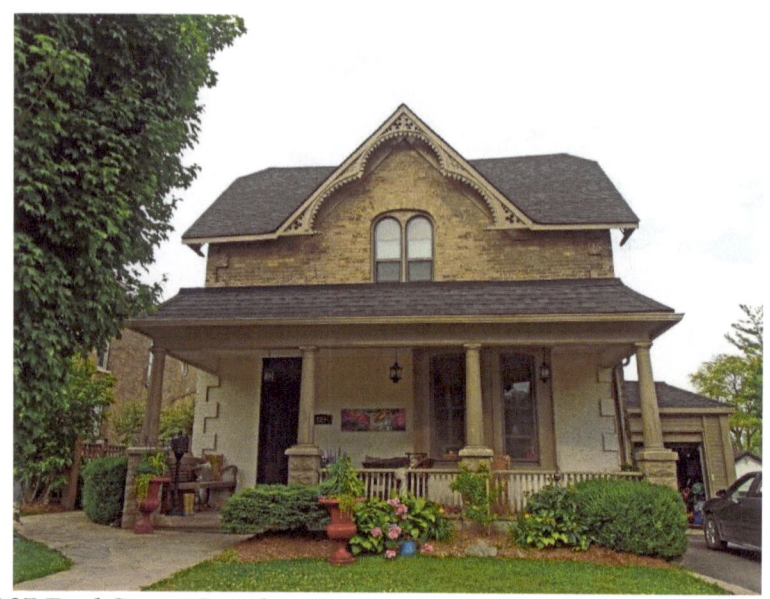

105 Peel Street South – Gothic, verge board trim on gable, Doric pillars for verandah supports, corner quoins

Peel Street South – vernacular

Peel Street South – cornice brackets, pediment

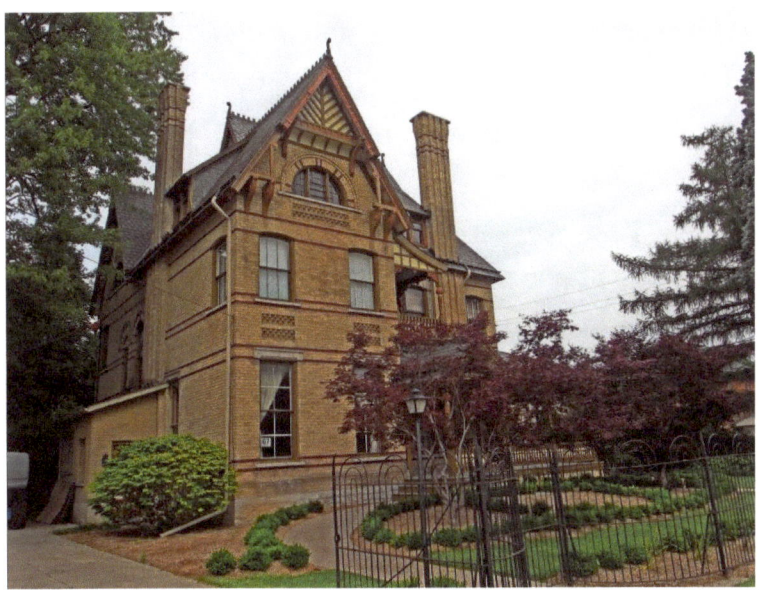

67 Peel Street South – built in 1883 for James Carter (wife Mary Box), only son of George Carter, a successful grain merchant in St. Marys – steep gable roofs, tall windows and chimneys with decorative brickwork – Queen Anne style

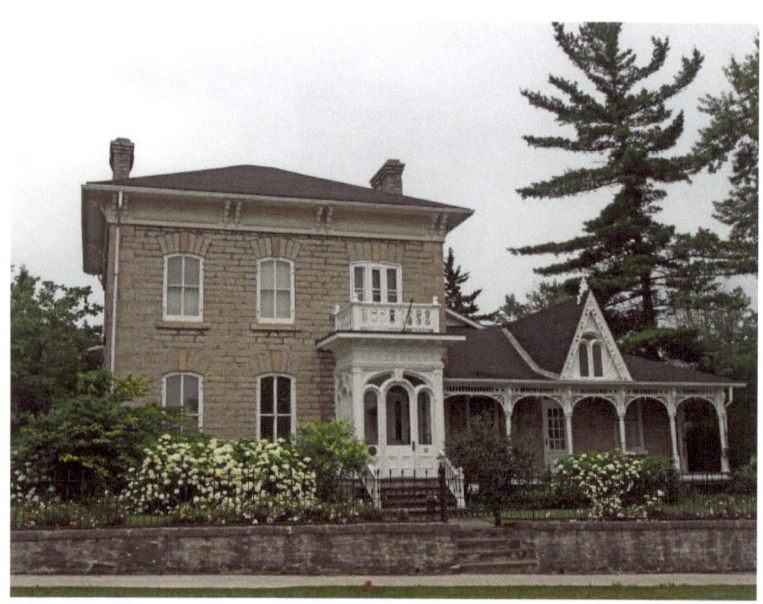

252 Queen Street East – John Sanderson built the Gothic style stone cottage on the right in 1850, verge board trim on gable; in 1869, he built the two storey Italianate addition - hipped roof, paired cornice brackets, voussoirs, second floor balcony above entrance

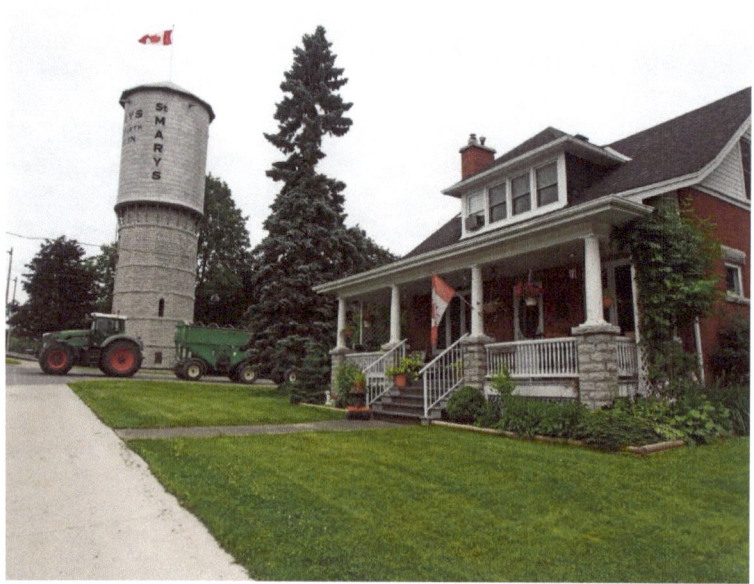

260 Queen Street East – Italianate, dormer in hipped roof, double-piered verandah supports

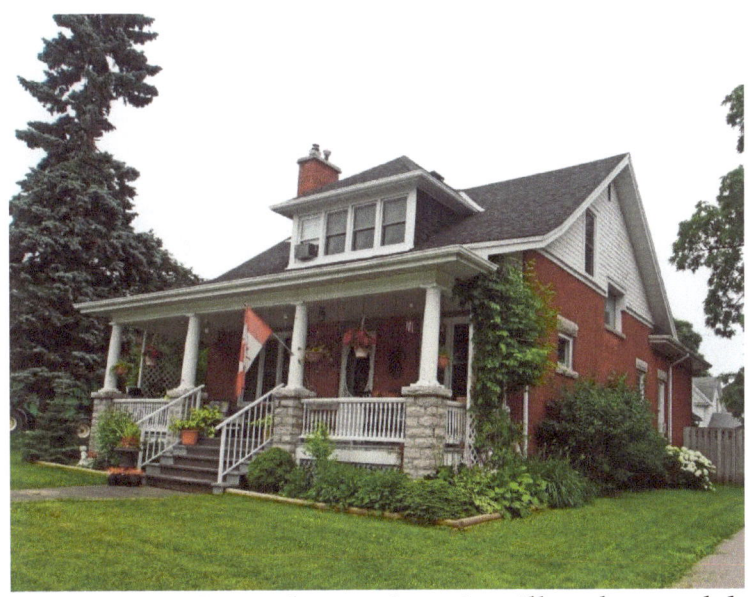

Queen Street East - dormer in attic, pillared verandah

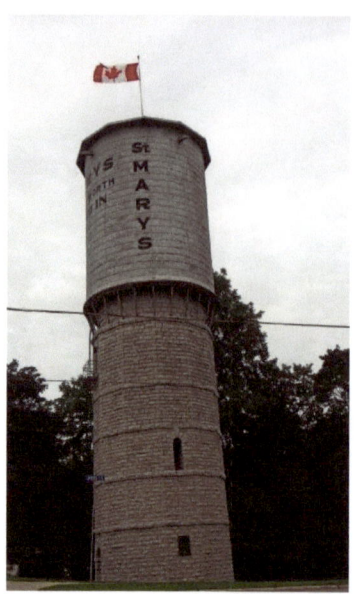

The solid stone water tower was built in 1899.

Italianate, limestone building, bay window, corner quoins

Dormer in hipped roof, second floor balcony

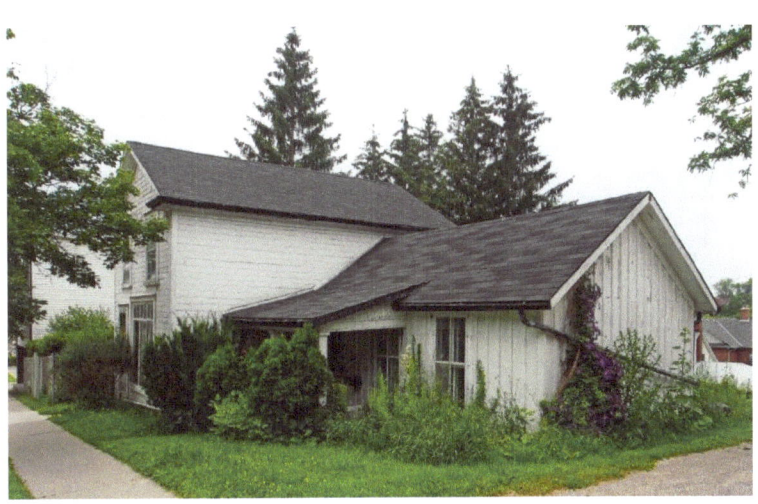

221 Queen Street East

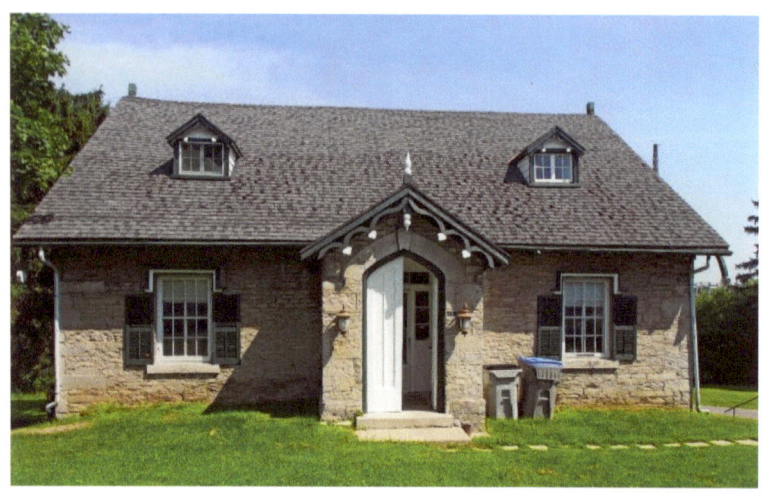

615 Queen Street East – Gothic - built in 1858 - limestone – dormers in attic, verge board trim on gable above door, and on end

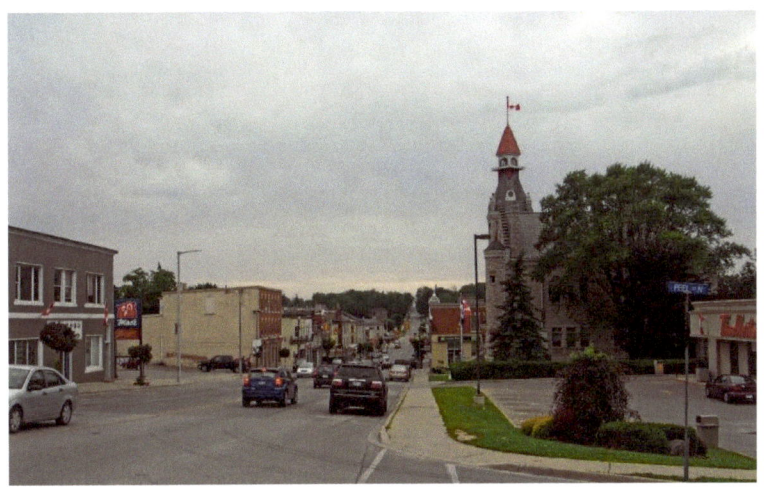

Queen Street East

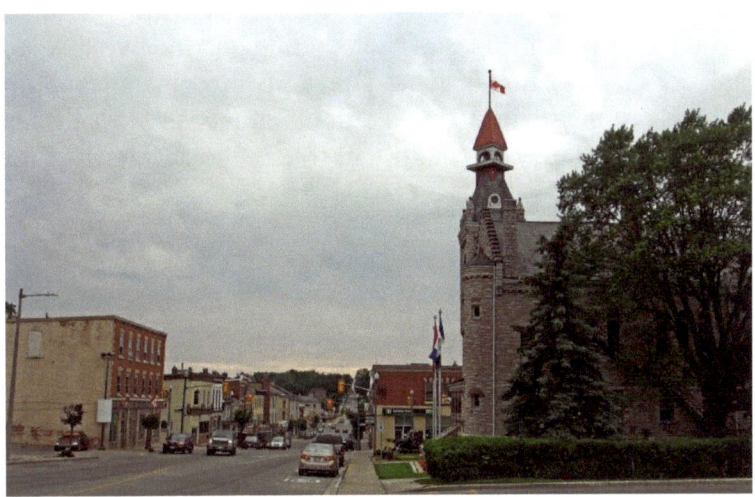

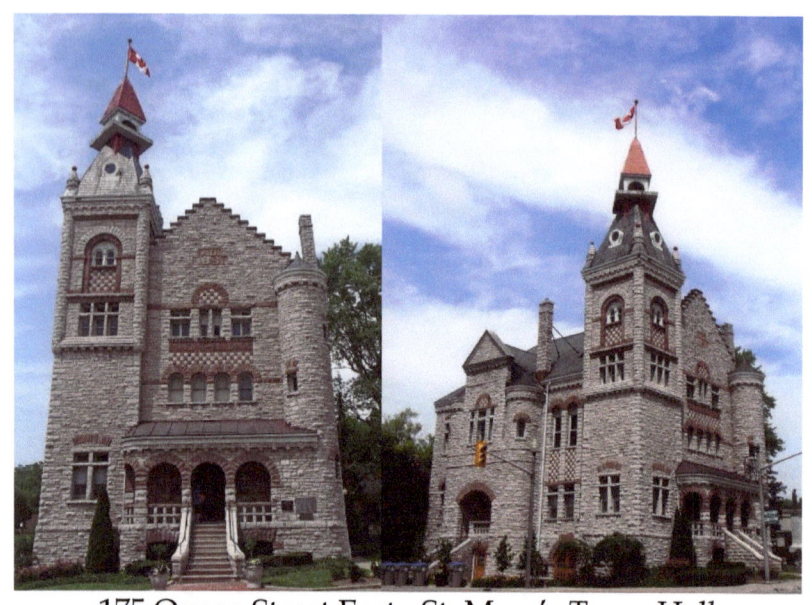

175 Queen Street East - St. Mary's Town Hall

This Romanesque Revival building was built in 1901 of local limestone with red sandstone as the contrasting elements for window arches and checkerboard effects in the façade. The massive entrances on the south and west façades of the building and the two towers on the south add to its lasting beauty. Due to its prominent location on the north side of the main street, and dominating as it does the skyline of the Town, it plays an important role in the character of the downtown area.

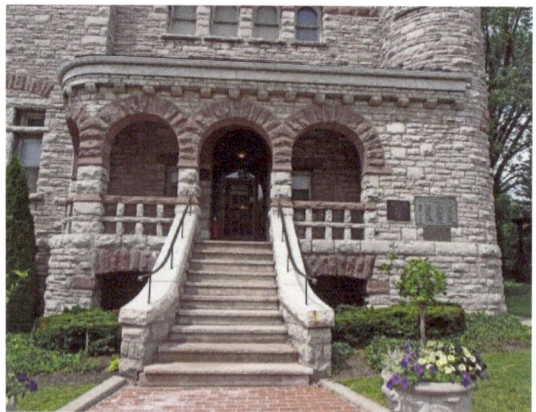

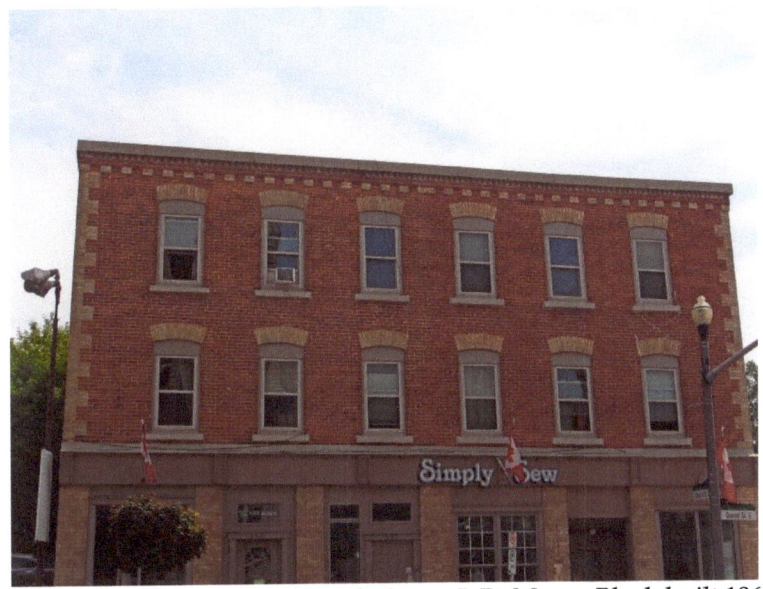

176-182 Queen Street East – Simply Sew – J. D. Moore Block built 1869 – three storeys, red brick trimmed with buff, corner quoins, voussoirs, dentil moulding

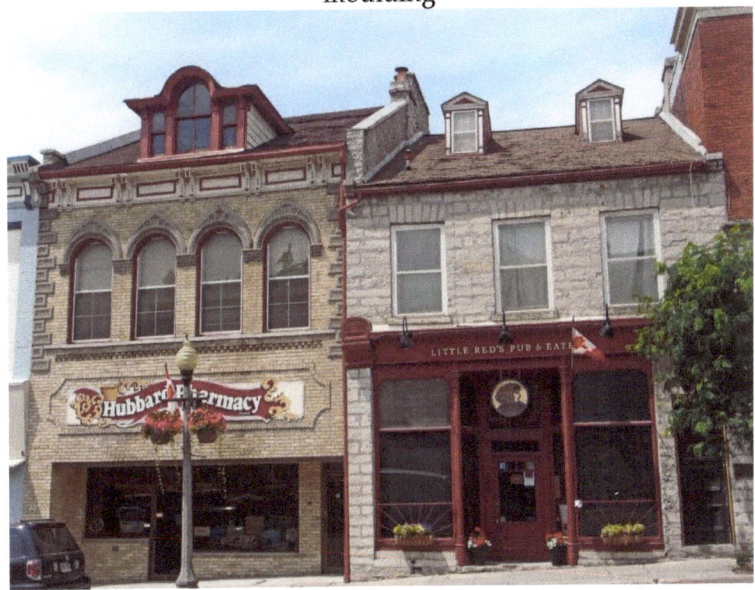

155 Queen Street East – Hubbard Pharmacy – built 1882 – Victorian style - dormer, decorative cornice and brackets

159-161 Queen Street East – Little Red's Pub & Eatery - George B. McIntyre Building built 1854 - limestone, dormers

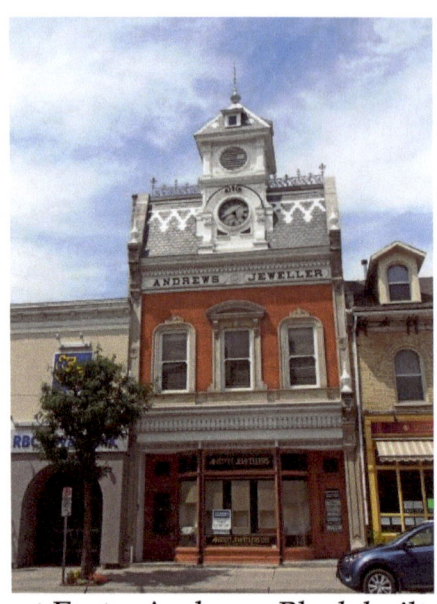

135 Queen Street East – Andrews Block built in 1884 – large two storeys with clock tower – Second Empire style – richly ornamented façade – white brick trimmed with red

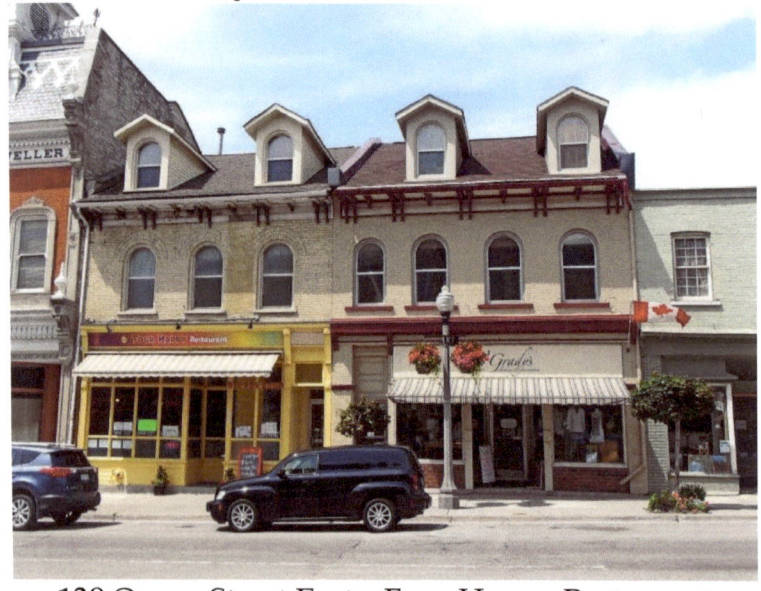

139 Queen Street East – Four Happy Restaurant
Dormers, cornice brackets

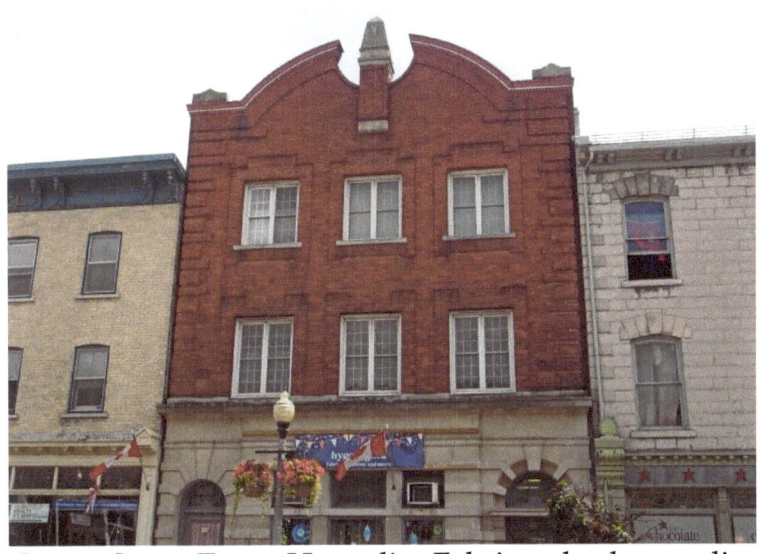

144 Queen Street East – Hyggeligt Fabrics – broken pediment, dentil moulding, corner quoins

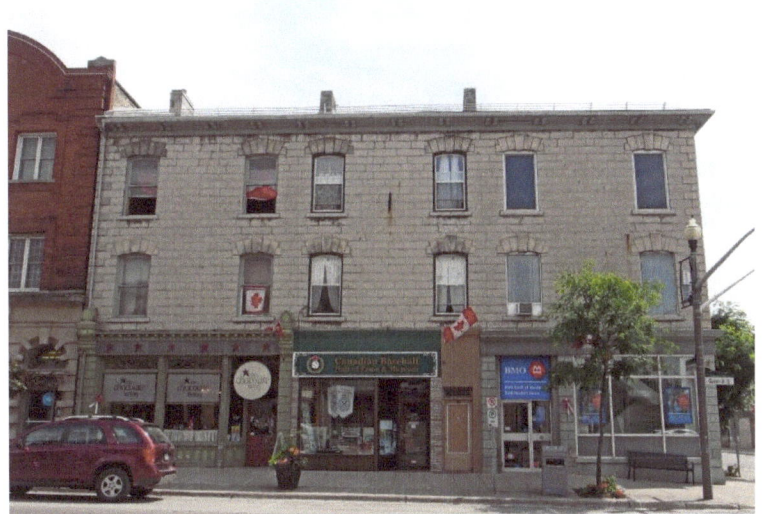

136-142 Queen Street East – The Chocolate Factory, Canadian Baseball Hall of Fame and Museum, Bank of Montreal - Guest Block built in 1868 – Classical Revival style

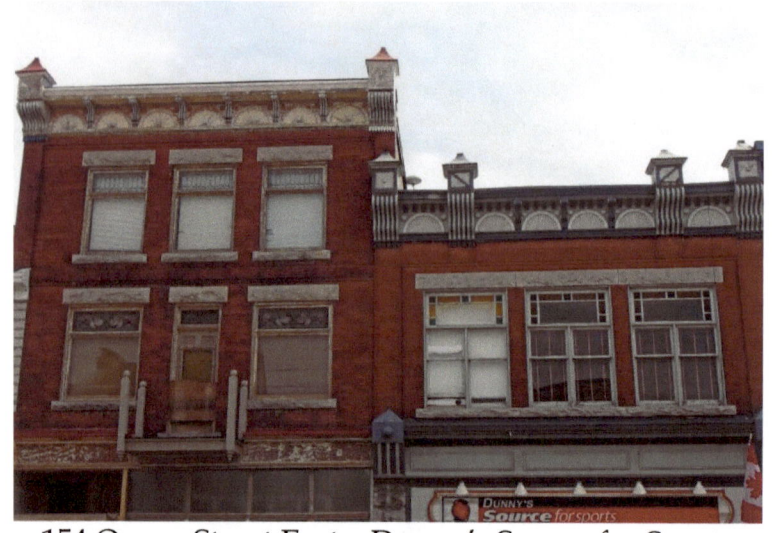

154 Queen Street East – Dunny's Source for Sports
Decorative cornices of both buildings, brackets, stained glass windows

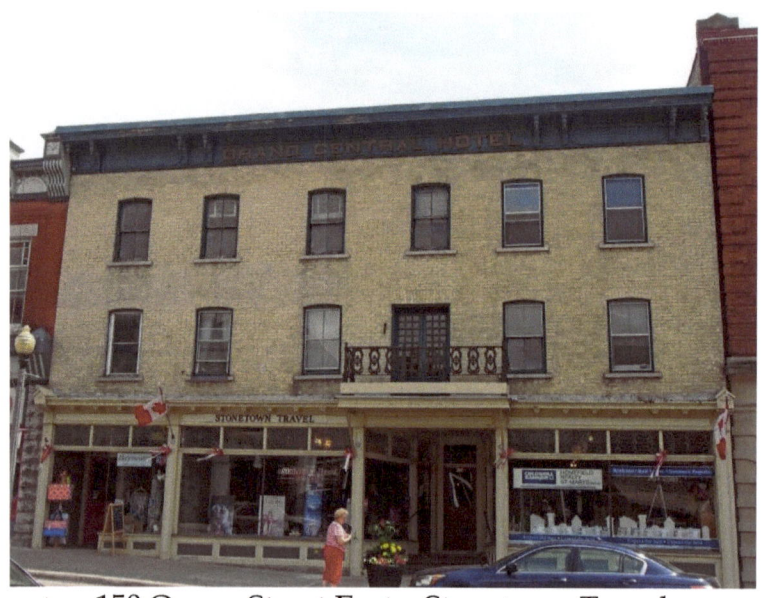

150 Queen Street East – Stonetown Travel
Paired cornice brackets, second floor balcony

172 Queen Street East

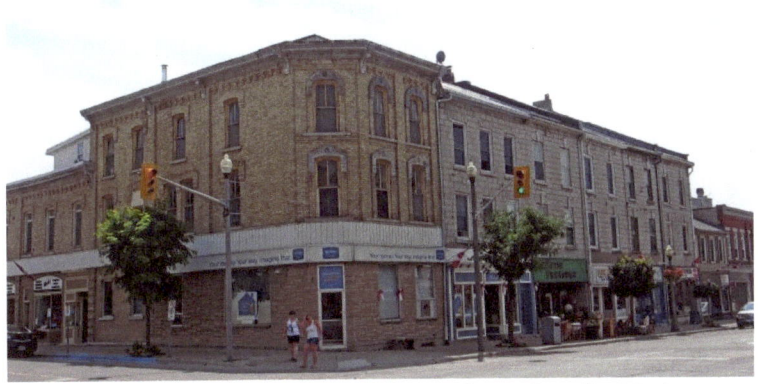

134 Queen Street East – Meridian Credit Union
Cornice brackets, bevelled dentil moulding, decorative window voussoirs

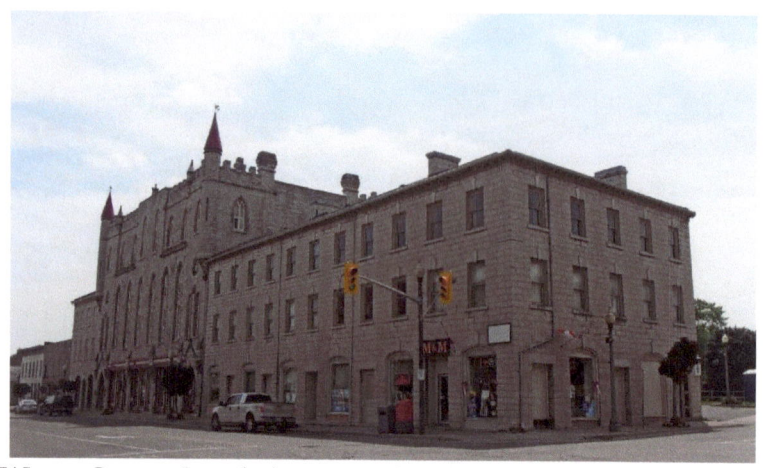

6 Water Street South (corner of Queen Street East) – Second Hutton Block built in 1863 – ten bay façade – segmental arches above the windows, voussoirs with projecting keystones give an Italianate flavour

122 Queen Street East – World's Coolest Music Store

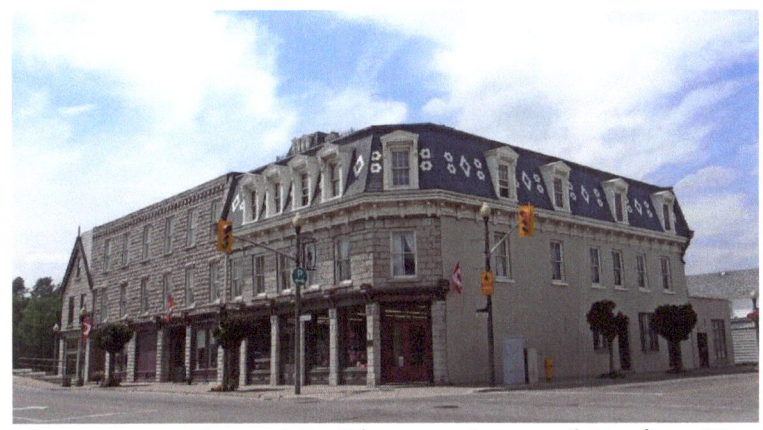

Queen Street East – MacPherson Arts and Crafts – First Hutton Block built in 1854; the third storey with a Mansard roof style was completed in 1884

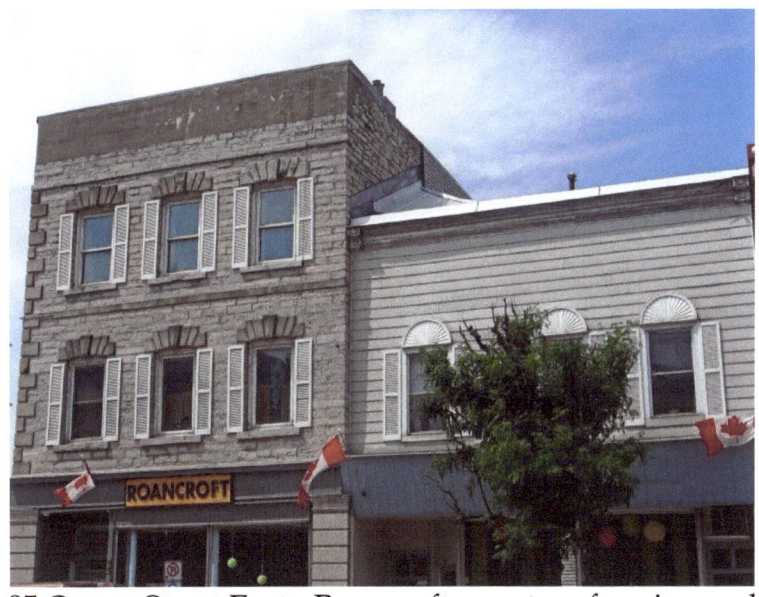

95 Queen Street East - Roancroft – custom framing and print shop – limestone building, corner quoins, voussoirs

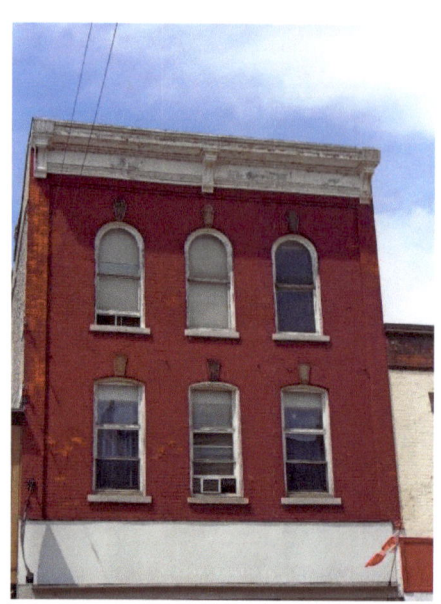

147 Queen Street East – Robert Eaton Building – built 1872 – red brick, keystones and voussoirs

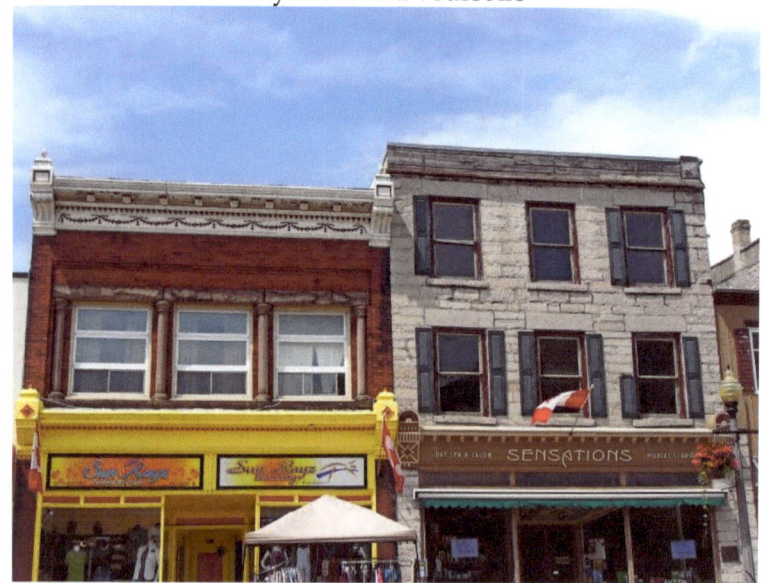

113 Queen Street East – Sun Rayz Tanning and Fashion Boutique – built 1904 - red brick with limestone accents in the lintels and pilasters – Queen Anne style influences – decorative cornice

115 Queen Street East – Sensations – built in 1859 – limestone blocks

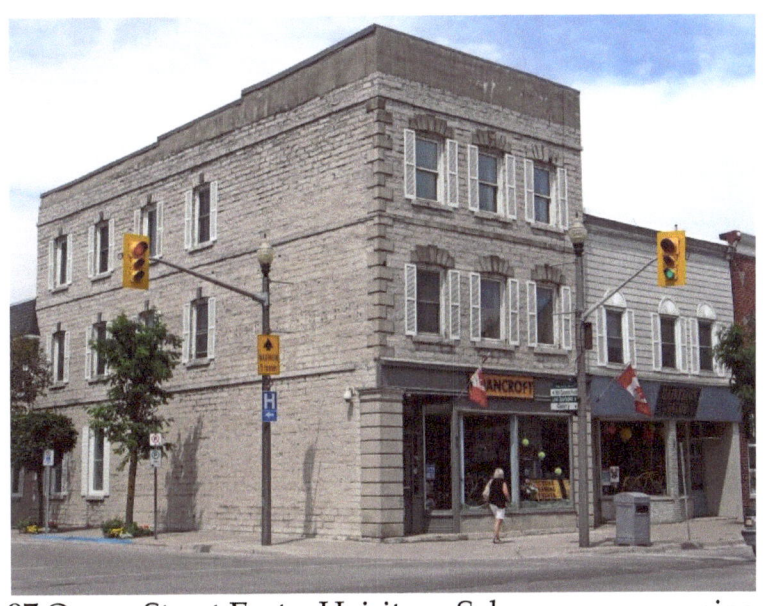

97 Queen Street East – Hairitage Salon – corner quoins, voussoirs with keystones

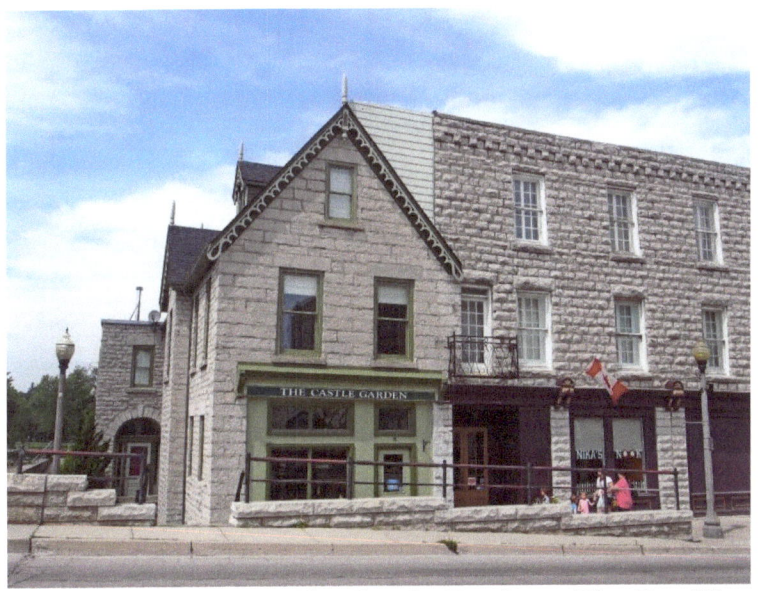

75 Queen Street East – The Castle Garden – The Box House built in 1886 built in flat coursed rubble limestone masonry – 2½ storeys – Gothic style

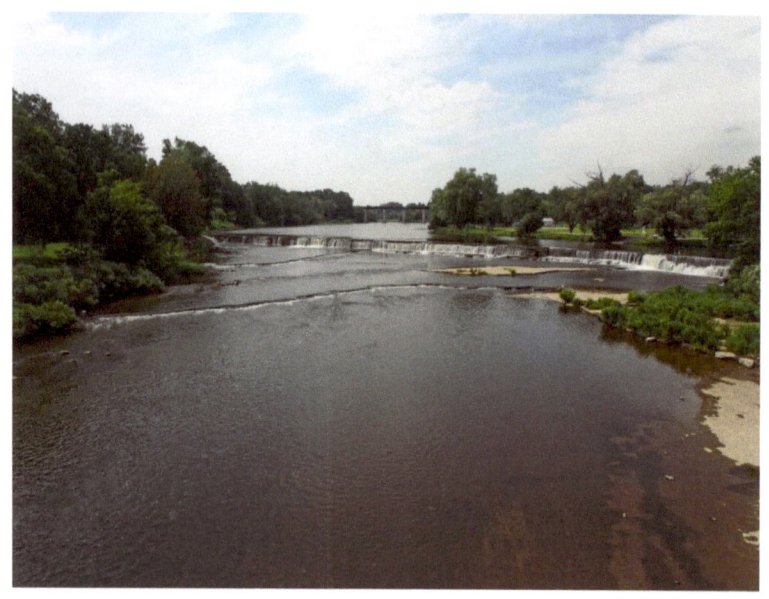

Thames River

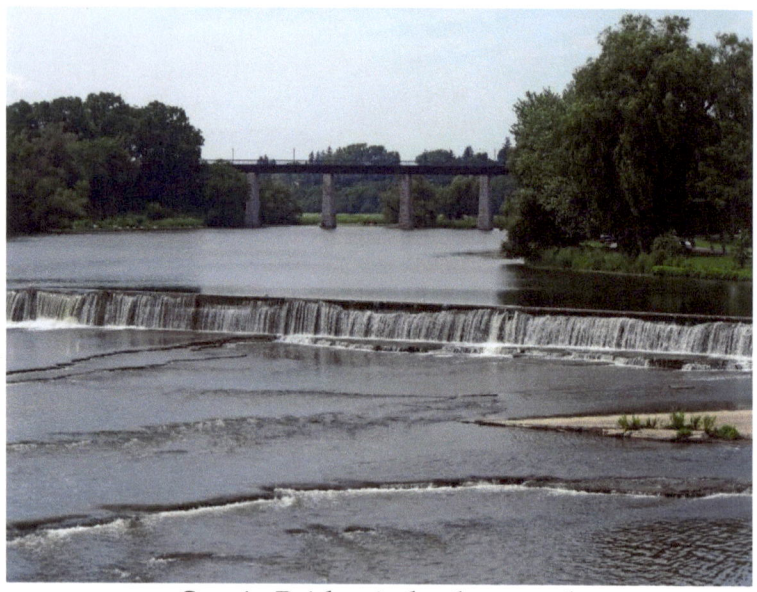

Sarnia Bridge in background

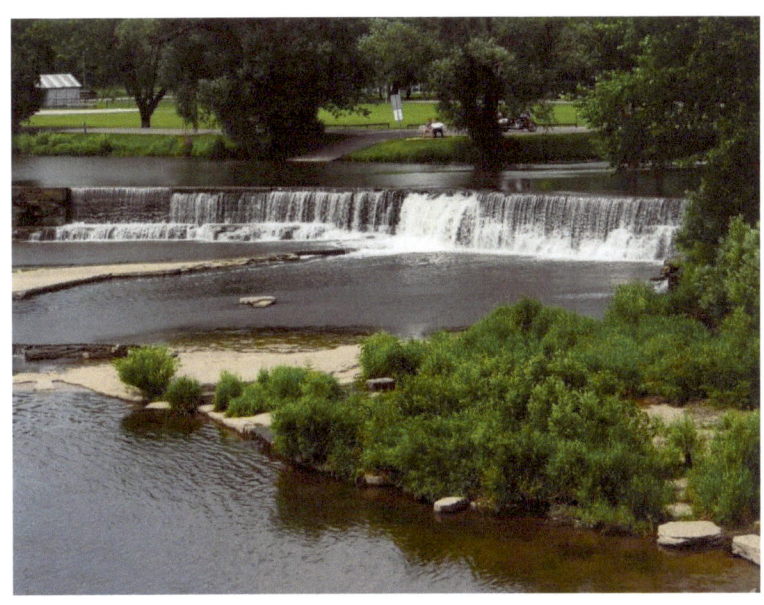

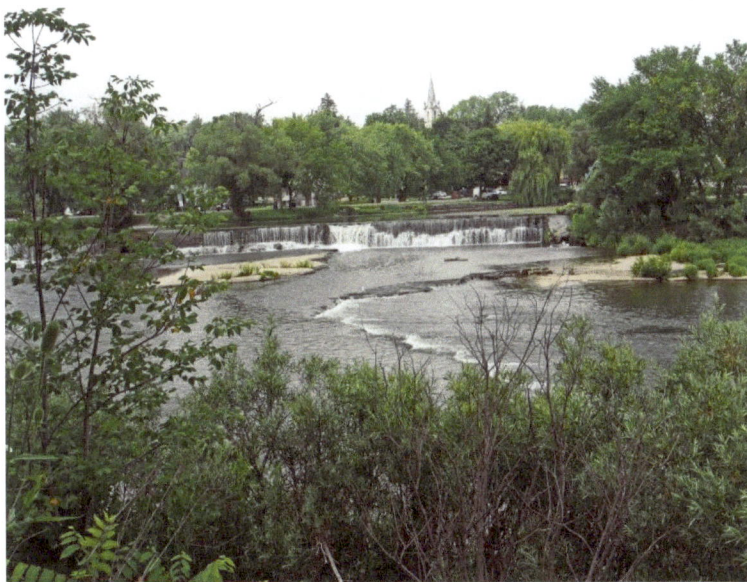

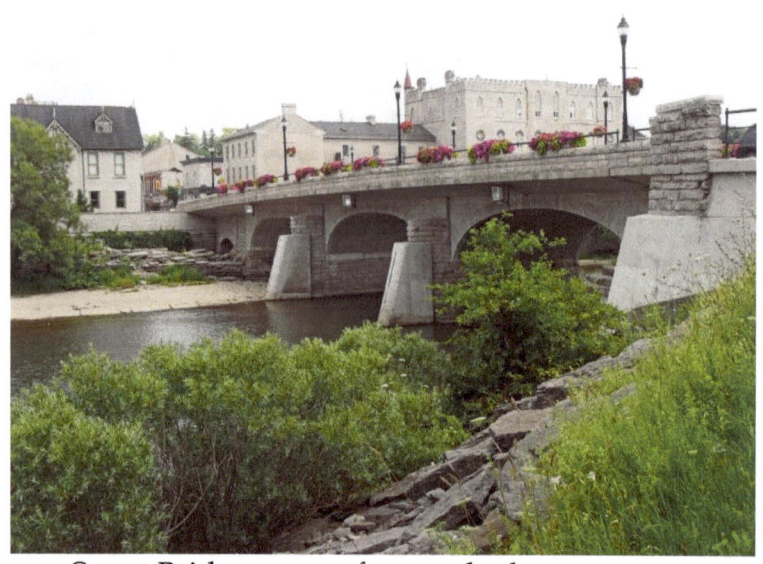

Queen Street Bridge - stone four-arched structure across the Thames River – constructed in 1865

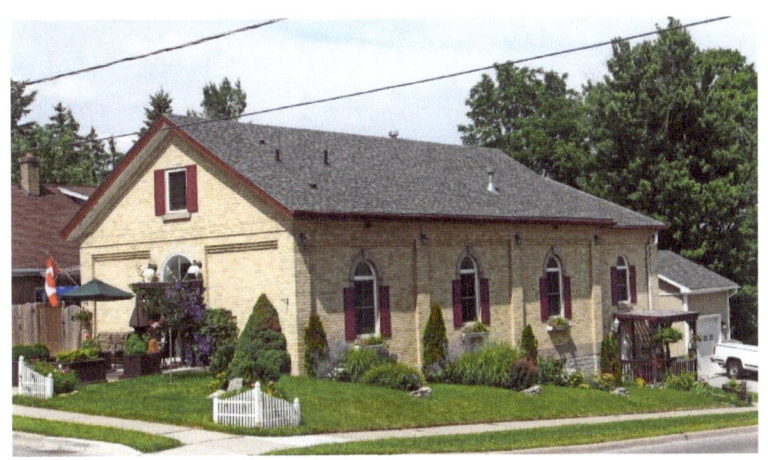
Keystones on the cement window hoods

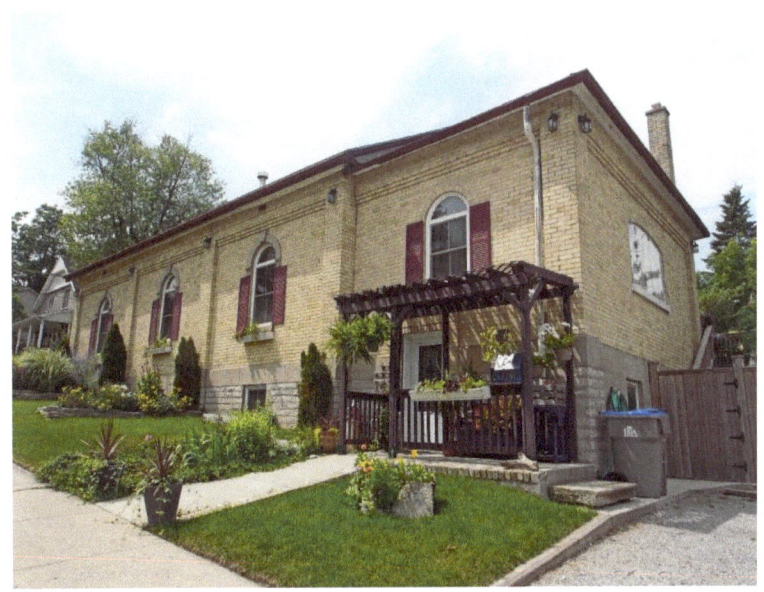
Queen Street West

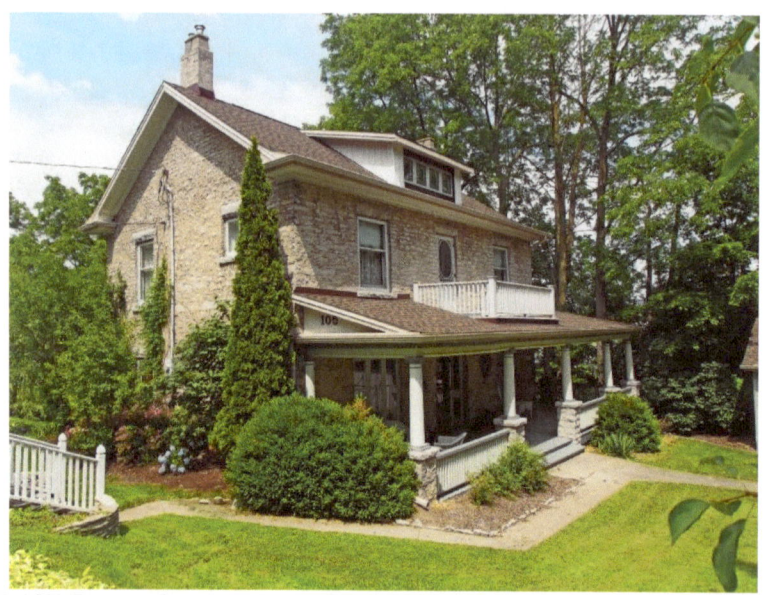

105-107 Queen Street West – built in 1843 for Thomas Ingersoll, St. Marys' founder - built with limestone quarried from the riverbed. It was redesigned in 1914 and converted from a 1½-storey into a 2½-storey house. A veranda was added and the basement excavated.

136 Queen Street West – Italianate – cornice brackets, two-storey tower-like bay

139-141 Queen Street West – built in the 1860s – limestone

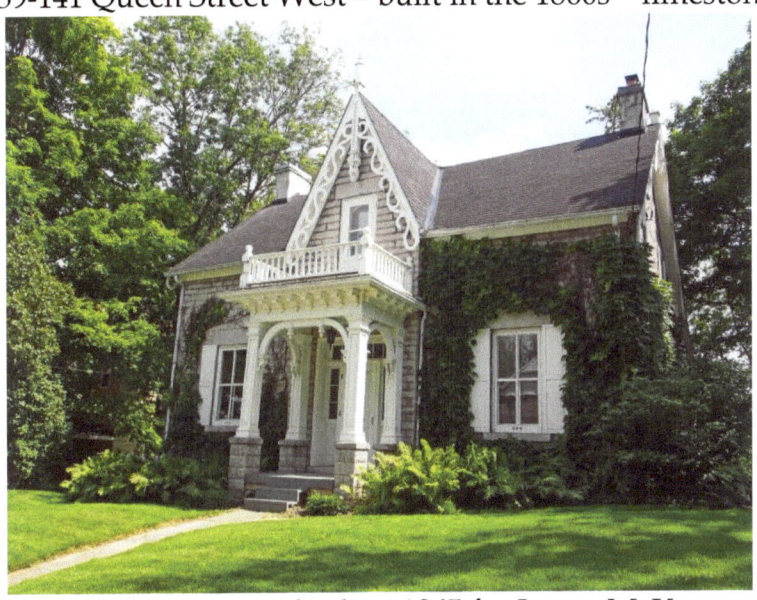

144 Queen Street West – built in 1865 for James McKay, one of St. Marys first inhabitants – the portico was added in the 1880s; Gothic Revival, verge board trim on gable with finial; transom and sidelights around door

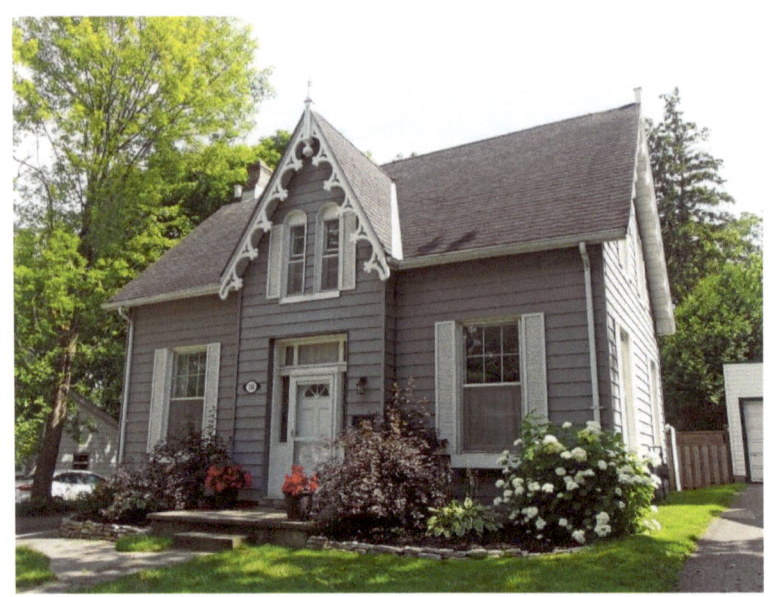

150 Queen Street West – Gothic Revival, verge board trim on gable, transom and sidelights around door

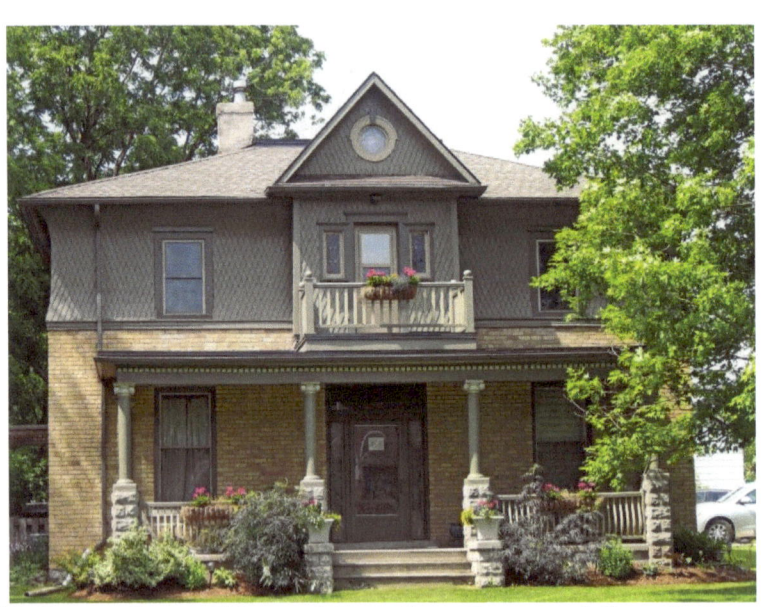

151 Queen Street West – hipped roof, second floor balcony, transom and sidelights around door

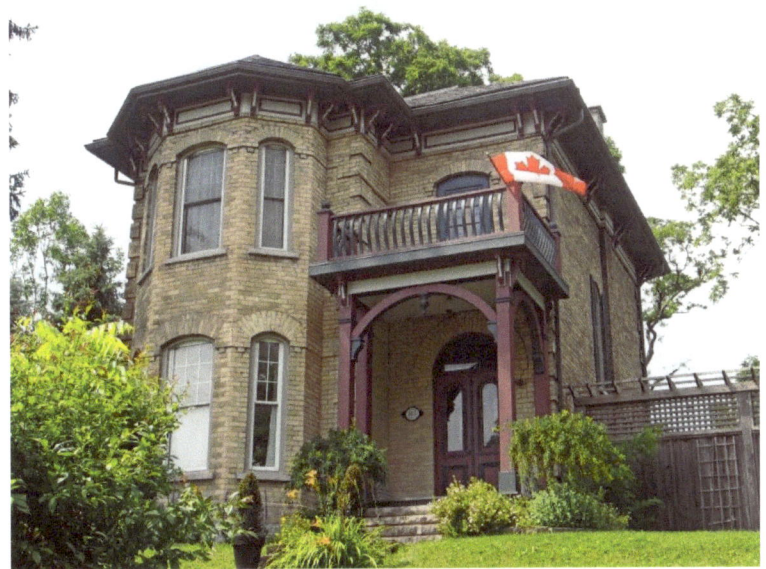

165 Queen Street West – built in 1881 for James Thompson, a grain dealer – Italianate, two-storey tower-like bay, second floor balcony, decorative cornice with brackets, corner quoins

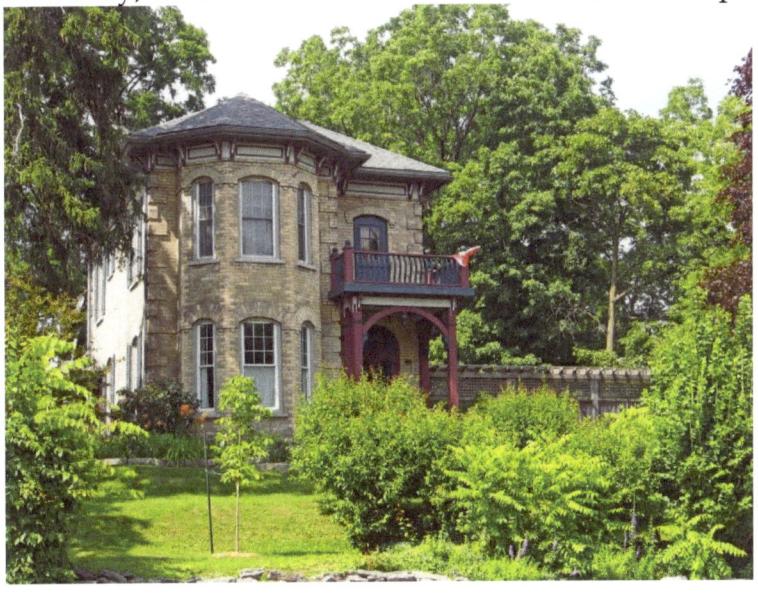

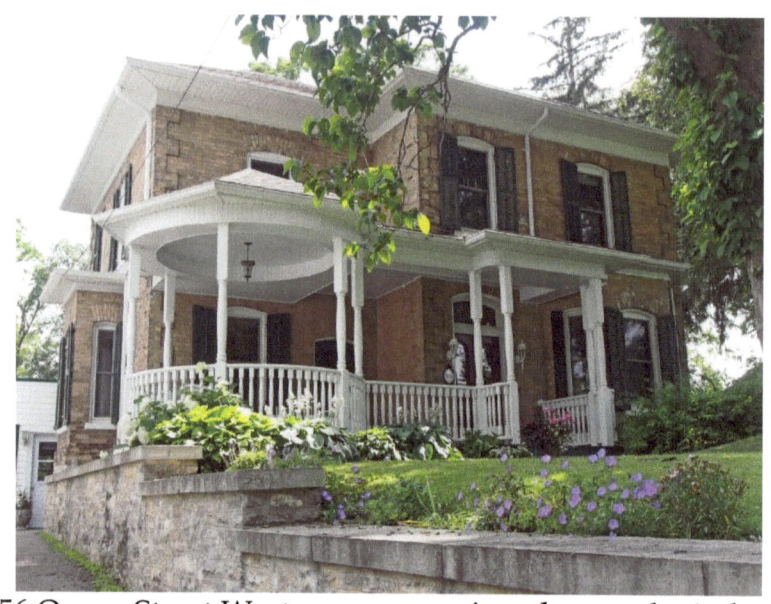

156 Queen Street West – corner quoins, shuttered windows with voussoirs, unique shaped verandah

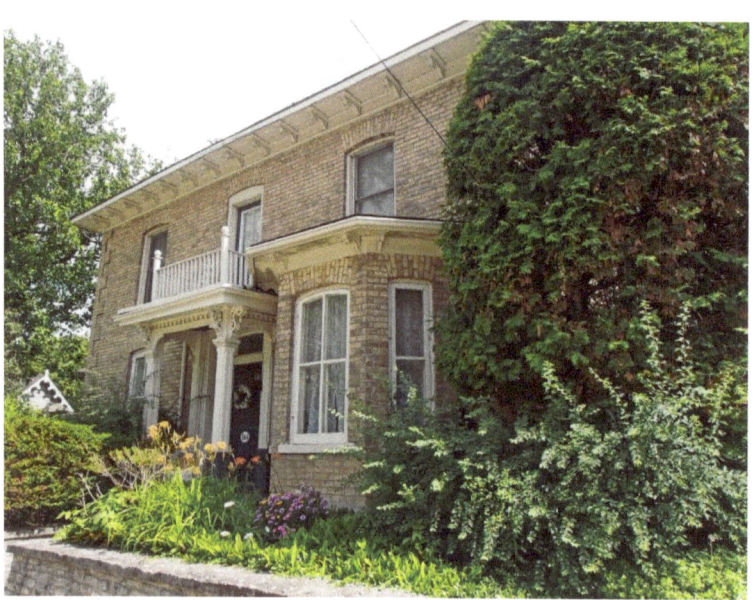

164 Queen Street West – cornice brackets, bay window, second floor balcony above entrance

178 Queen Street West – Italianate - two-storey tower-like bay, dormer, cobblestone architecture

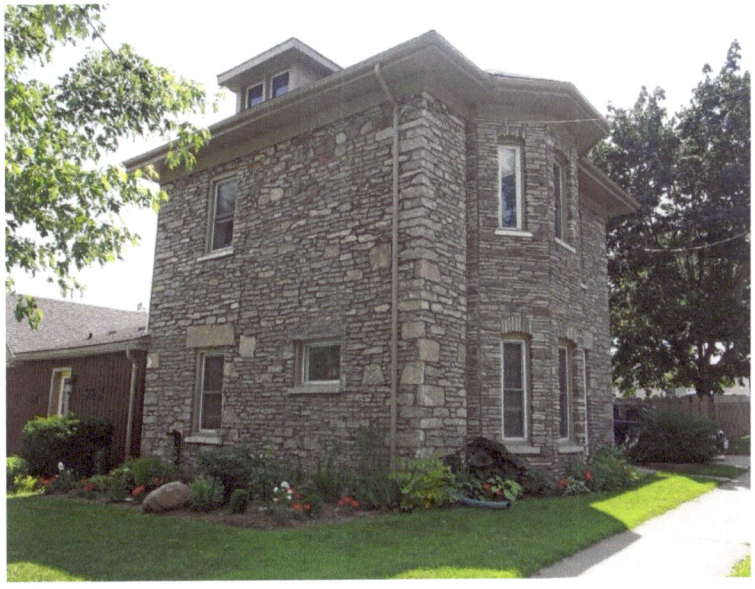

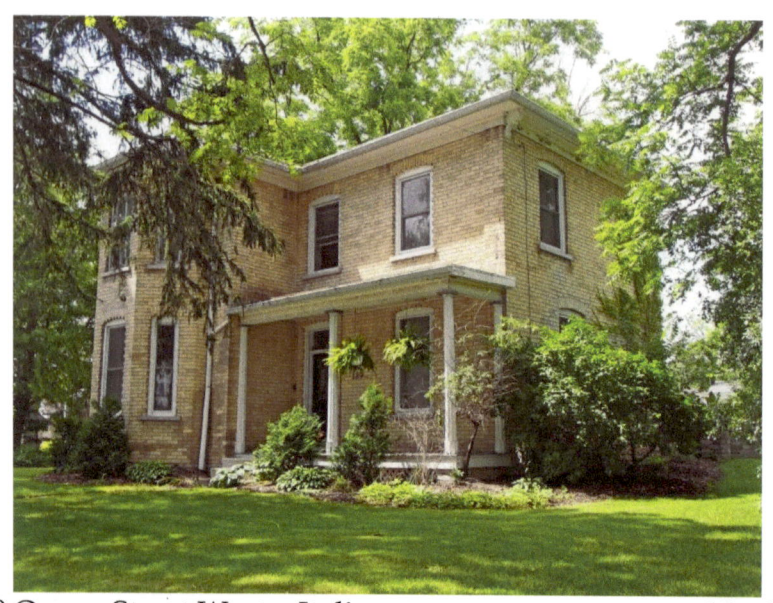

189 Queen Street West – Italianate – two-storey tower-like bay

211 Queen Street West – hipped roof

205 Queen Street West – hipped roof, pediments with decorated tympanums

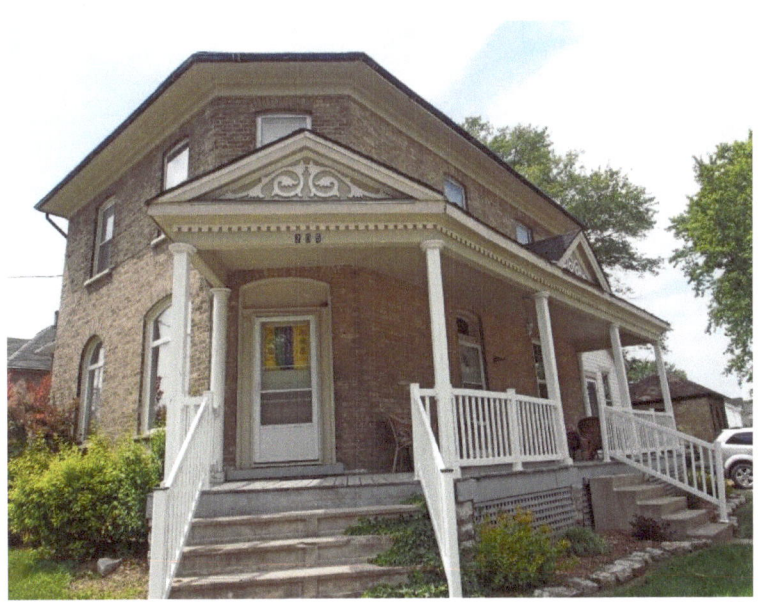

212 Queen Street West – Regency Cottage, corner quoins

216 Queen Street West – Gothic Revival

225 Queen Street West – two-storey tower-like bay

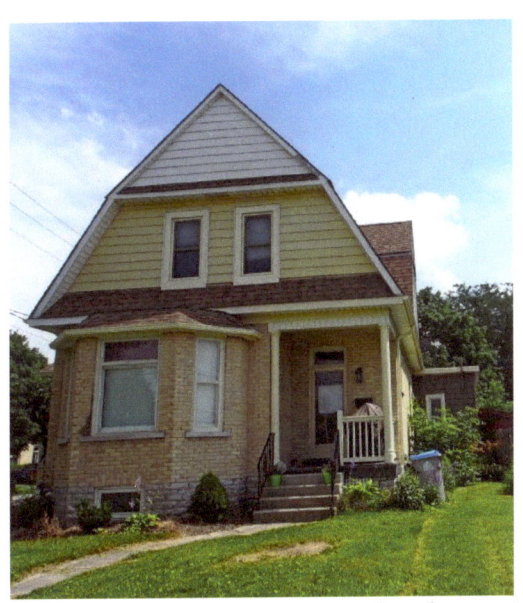

236 Queen Street West – vernacular, bay window

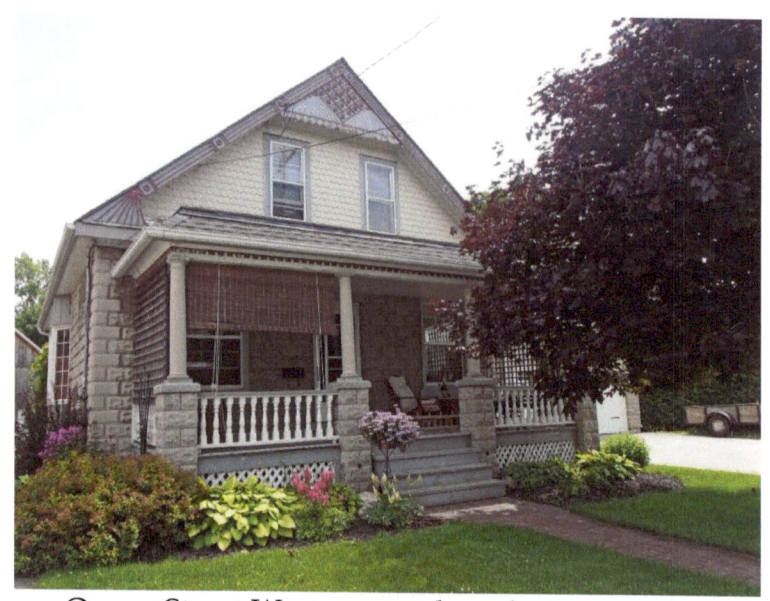

Queen Street West – verge board trim on gable

240 Queen Street West - Edwardian

241 Queen Street West – Perth County EMS

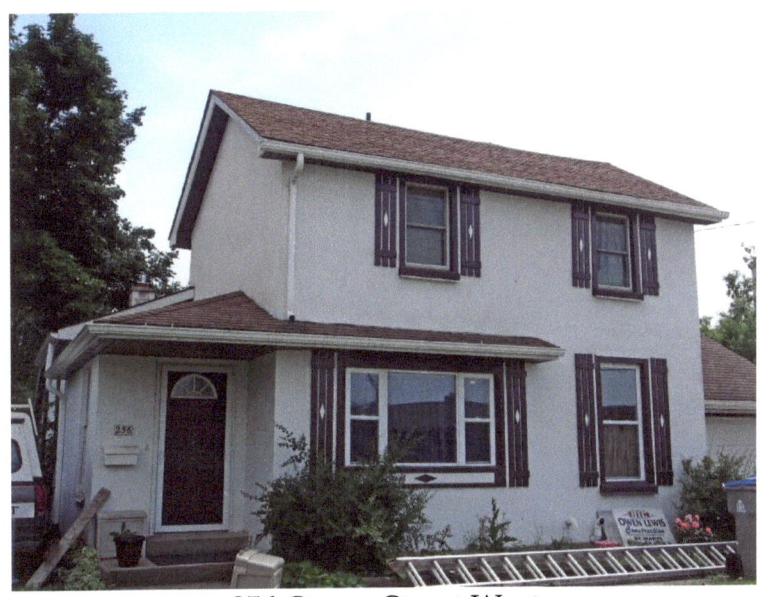

256 Queen Street West

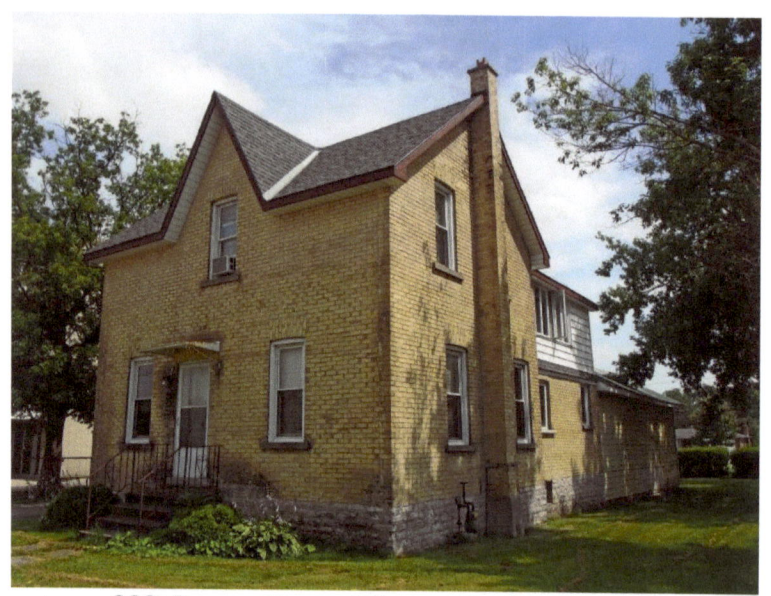

282 Queen Street West – Gothic Revival

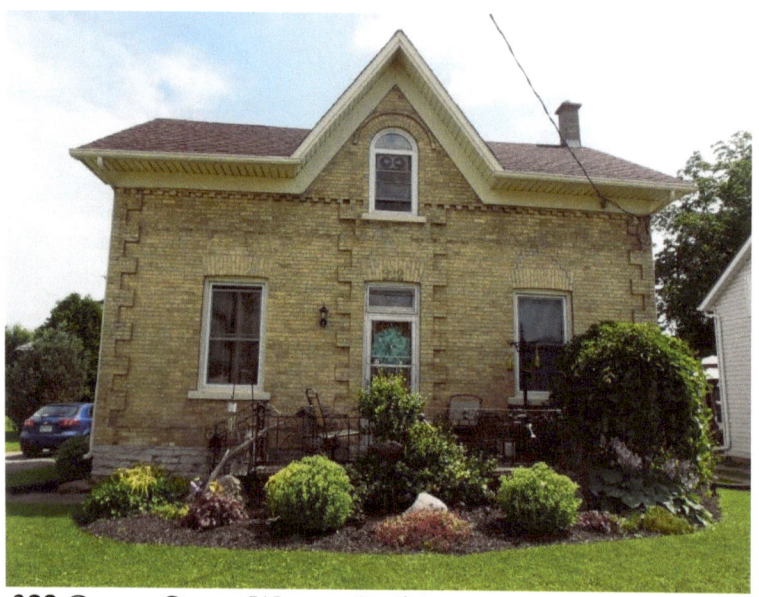

322 Queen Street West – Gothic, corner quoins, dentil moulding below eaves

Architectural Terms

Bay Window: A window that projects out from a wall, in a semicircular, rectangular, or polygonal design. Used frequently in Gothic and Victorian designs. Example: 164 Queen Street West, Page 50	
Brackets: a decorative or weight-bearing structural element which forms a right angle with one side against a wall and the other under a projecting surface such as an eave or roof. Example: 165 Queen Street West, Page 43	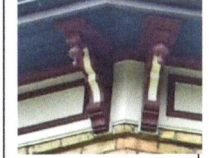
Cobblestone architecture: Refers to the use of cobblestones embedded in mortar as a method for erecting walls on houses and commercial buildings. Example: 178 Queen Street West, Page 45	
Cornice: originally the wooden overhang of the roof. With the use of stone, brick, iron and steel, the cornice is any projecting shelf at the top of a ceiling or roof. They can be very decorative. Example: Queen Street East, Page 34	
Cornice Return: decorative element on the end of a gable. Example: 196 Park Street, Page 11	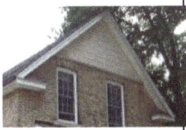

Dentil Moulding: an even series of rectangles used as ornamental decoration in cornices. Example: Peel Street South, Page 19	
Dormer: (French for "sleep") a gable end window that pierces through the plane of a sloping roof surface to create usable space in the top floor or attic of a building by adding headroom. Example: 36 Ontario Street South, Page 7	
Entrance: The entrance encompasses the doorway and the inner vestibule or, in residential architecture, the covered porch. Example: 144 Queen Street West, Page 41	
Gable: the triangular portion of a wall between the edges of a sloping roof. Example: 105 Peel Street South, Page 18	
Gambrel Roof: a symmetrical two-sided roof with two slopes on each side; the upper slope is positioned at a shallow angle, while the lower slope is steep. It is similar to a mansard roof, but a gambrel has vertical gable ends instead of being hipped at the four corners of the building. Example: 48 Ontario Street South, Page 9	
Hipped Roof: a roof where all sides slope downwards to the walls with no gables. Example: 35 Ontario Street South, Page 8	

Keystones and Voussoirs: a voussoir is a wedge-shaped element used in building an arch. A keystone is the central stone that locks all the stones into position, allowing the arch to bear weight. A keystone is often enlarged and embellished. Example: 252 Queen Street East, Page 20	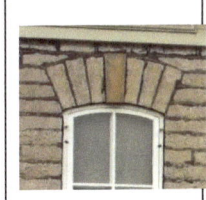
Pediment: a triangular section above the horizontal structure (entablature), typically supported by columns. The inside of the triangle is called the tympanum. Example: Peel Street South, Page 19	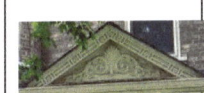
Quoin: masonry blocks at the corner of a wall, often a decorative feature, usually larger or of a different colour than the rest of the wall. Example: 156 Queen Street West, Page 44	
Sidelight: a window, usually with a vertical emphasis, that flanks a door, and is often used to emphasize the importance of a primary entrance. **Transom Window:** the light above the doorway, also called a fanlight. Example: 26 Ontario Street South, Page 7	
Verge board and Finial: also called bargeboards – hang from the projecting end of a roof and are often elaborately carved and ornamented. **Finial:** ornament added to the top of a gable, pinnacle, canopy or spire – a Gothic element. Example: 144 Queen St. West, Pg. 41	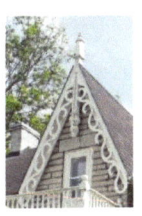

Building Styles

Cape Dutch architecture is a traditional Afrikaner architectural style found mostly in the Western Cape of South Africa. The initial settlers of the Cape were primarily Dutch. When the Dutch came to Ontario, they brought with them building concepts from their own native lands. Architecture from the 18th and early 19th centuries in Ontario includes a wide assortment of detailing and ornament all applied to a basic building design centred around the fireplace and the source of water. Example: 48 Ontario Street South, Page 9	
Classical Revival (1820 - 1860) – This style was an analytical, scientific, and dogmatic revival based on intensive studies of Greek and Roman buildings, concerned with the application of Greek plans and proportions to civic buildings. Schools, libraries, government offices, and most other civic buildings were built in the Classical Revival style. The white columned porches of the Classical Revival domestic buildings are identified with the mansions of wealthy land owners in Canada. Example: 136-142 Queen Street East, Page 29	

Edwardian, 1900-1930 – This style bridges the ornate and elaborate styles of the Victorian era and the simplified styles of the 20th century. Balanced facades, simple roof lines, dormer windows, large front porches, and smooth brick surfaces are its characteristics. Example: 240 Queen Street West, Page 50	
Gothic Revival, 1830-1890 – These decorative buildings have sharply-pitched gables with highly detailed verge boards, pointed-arch window openings, and dichromatic brickwork. It is a common style in Ontario. Example: 105 Peel Street South, Page 18	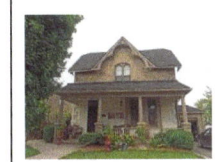
Italianate, 1850-1900 – It has wide-bracketed eaves, belvederes, wrap-around verandahs. Example: 136 Queen Street West, Page 40	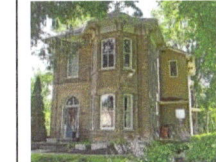
Queen Anne, 1885-1900 – This style is distinguished by an irregular outline featuring a combination of an offset tower, broad gables, projecting two-storey bays, verandahs, multi-sloped roofs, and tall, decorative chimneys. A mixture of brick and wood is common. Windows often have one large single-paned bottom sash and small panes in the upper sash. Example: 67 Peel Street South, Page 19	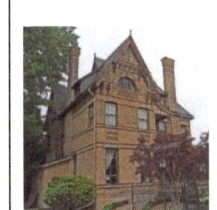

Regency Cottage, 1830-1860 – This style originated in England in 1815 and spread to Ontario later in the 19th century as British officers retired to Canada. It is a modest one-storey house with a low-pitched hip roof and has a symmetrical front façade. Example: 145 Peel Street South, Page 15	
Romanesque Revival, 1880-1910 – This style hearkens back to medieval architecture of the 11th and 12th centuries with a heavy appearance, blocky towers and rounded arches. Example: 175 Queen Street East, Page 26	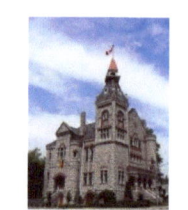
Second Empire, 1860-1880 – The mansard roof is the most noteworthy feature of this style and is evidence of the French origins. Projecting central towers and one or two-storey bays can also be present. Example: 135 Queen Street East, Page 28	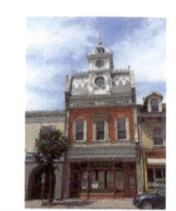
Vernacular/Traditional Mode 1638 - 1950 Influenced but not defined by a particular style, vernacular buildings are made from easily available materials and exhibit local design characteristics. Example: 236 Queen Street West, Page 49	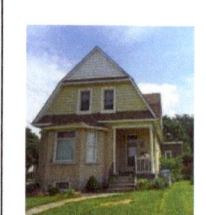
Victorian - In Ontario, a Victorian style building can be seen as any building built between 1840 and 1900 that doesn't fit into any of the other categories. It encompasses a large group of buildings constructed in brick, stone, and timber, using an eclectic mixture of Classical and Gothic motifs. Example: 155 Queen Street East, Page 27	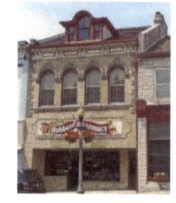

www.ingramcontent.com/pod-product-compliance
Lightning Source LLC
Chambersburg PA
CBHW040853180526
45159CB00001B/407